FINDING FREEDOM
to
Create

Also by Dianne Mize

In Praise of Mountain Waters: Paintings of Rivers, Waterfalls and Streams in Northeast Georgia

Notan: A Painter's Guide for Composing Darks and Lights

Available from:
www.amazon.com
www.createspace.com

FINDING FREEDOM to Create

A Painter's Roadmap

DIANNE MIZE

BALBOA PRESS
A DIVISION OF HAY HOUSE

Copyright © 2014 Dianne Mize.

All rights reserved. No part of this book may be used or reproduced by any means, graphic, electronic, or mechanical, including photocopying, recording, taping or by any information storage retrieval system without the written permission of the publisher except in the case of brief quotations embodied in critical articles and reviews.

Balboa Press books may be ordered through booksellers or by contacting:

Balboa Press
A Division of Hay House
1663 Liberty Drive
Bloomington, IN 47403
www.balboapress.com
1 (877) 407-4847

Because of the dynamic nature of the Internet, any web addresses or links contained in this book may have changed since publication and may no longer be valid. The views expressed in this work are solely those of the author and do not necessarily reflect the views of the publisher, and the publisher hereby disclaims any responsibility for them.

The author of this book does not dispense medical advice or prescribe the use of any technique as a form of treatment for physical, emotional, or medical problems without the advice of a physician, either directly or indirectly. The intent of the author is only to offer information of a general nature to help you in your quest for emotional and spiritual well-being. In the event you use any of the information in this book for yourself, which is your constitutional right, the author and the publisher assume no responsibility for your actions.

Any people depicted in stock imagery provided by Thinkstock are models, and such images are being used for illustrative purposes only.
Certain stock imagery © Thinkstock.

All illustrations and paintings by Dianne Mize.

Printed in the United States of America.

ISBN: 978-1-4525-9694-5 (sc)
ISBN: 978-1-4525-9696-9 (hc)
ISBN: 978-1-4525-9695-2 (e)

Library of Congress Control Number: 2014907672

Balboa Press rev. date: 04/30/2014

To my students then and now, without whose desires to find their true voices, I could not be a teacher.

And for my beloved Howard, whose spirit lives close within and who taught me that true creative freedom comes when one relaxes into the person one was born to be.

CONTENTS

PREFACE	xv
1 THE ESSENCE OF CREATIVE FREEDOM	1
Individual Uniqueness	1
Style: The Artist's Hand	4
The Creative Current	5
2 CRAFT: THE ARTIST'S VOICE	10
The Decline of Craft	11
The Return of Craft	12
Restrictive Practices	13
Keeping Your Own Voice	18
3 SEEING: THE ARTIST'S RESOURCE	20
Let's Draw	22
The Air Glide Exercise	22
The Phantom Drawing Exercise	23
The Cruising Exercise	24
How to Look at Your Drawing	26
Seeing as Your Resource	27
4 COMPOSING: THE HEARTBEAT OF EXPRESSION	29
The Means Is the Messenger	30
Born Knowing	31
Demystifying the "Principles" of Composition	32
A New Name, A New Way of Thinking	33
The Composing Generators	34
Generators' Roles	35
5 HOW COMPOSING WORKS	36
The Results Generators	37
Order and Unity	37
Harmony	38
Balance	38
Rhythm	39

Movement	40
Proportion	41
The Magic Continuum	42
The Worker Generators	43
Selecting and Placing	43
Contrasting and Emphasizing	51
Transitions: Gradating and Modulating	51
Repeating and Varying	54
Elaborating and Economizing	55
Isolating	56
Overlapping	56
Converging	57
Assigning Dominance	61
Summing It Up	62

6 THE VOCABULARY OF COMPOSING 63

Our Seeing Awareness	64
Value: The Supreme Element	65
Color: The Element of Multiples	66
Dissecting Color	66
The Color Wheel	67
Color and Music	67
The Physical Nature of Color	69
Shape: The Element of Limitations	73
Texture: The Element of Intrigue	74
Line: The Leading Element	75
Direction: The Guiding Element	76
Size: The Relational Element	77
Wrapping Up the Vocabulary	79
There is No *Correct* Way to Compose	80

7 THE COMPOSING PROCESS 82

Translating	82
From Strategy to Creation	83
The Notan	83
From Thinking to No-thinking	86
A Brief Journal of Observing and Translating	87
Bringing in Color	90

From Notan to Color 90
Translating Color 92
Transposing versus Translating 92
 Color Schemes for Translating and Transposing 94
 Color Schemes as Strategy 97
The Image Solution 101
Visual Paths as Strategies 101
 A Single Unifying Device 104
Composing Trip-ups 106
The Space Between 111
When Not to Think 112
When Not to Compose 114
Convention Breakers 115
The Zen of Composing 116

8 CLAIMING CREATIVE FREEDOM 118
Deleting Fear 118
There Is No Correct Way to Draw 120
 The Power of Gesture 121
 Approaching Gesture Drawing 124
 Discovering Movement and Drawing It 130
The "Correct Way" Myth about Drawing 131

9 CREATIVE FREEDOM IS IMMINENT 134
How Do We Evaluate the Work? 135
What Makes a Masterful Painting? 140

EPILOGUE 143
Nature as Our Guide 143
Going Forward 144

ACKNOWLEDGMENTS 145

RECOMMENDED READING 147

ABOUT THE AUTHOR 149

Art is neither a profession nor a hobby. Art is a way of being.

—Frederick Franck, *Zen Seeing, Zen Drawing*

We are each born with a uniqueness that is our individuality. If we exchange that uniqueness for a mask of any kind, we will not fully realize our purpose on this earth: it is within that part of ourselves where we are truly free.

—Dianne Mize,
*Dianne Mize Studio Catalogue,
1984-2007*

PREFACE

At nine years old, I gazed spellbound as a potter shaped a pot from a lump of clay. I wanted to see it again and again and again. I rattled off question after question as he worked. I dogged his every step as he moved around the shop. It was a defining day. I wanted to do that.

I pulled my brother's red wagon down to the creek to look for clay. The potter had explained how to spot the good stuff, avoid the inferior, and ways to dig and process it. I still can feel the excitement of discovering an abundance of the good, slick, soggy dirt. It smelled fresh and alive just like the huge pile behind the potter's shop.

With the potter's studio in mind, I scavenged odds and ends from my father's workshop, and in an old outbuilding I fashioned my own potter's shop. I set out to process the clay just as the potter had done and then to find ways to form my own little pots.

There was a joy and exhilaration having shapes form within my hands. All awareness of time stopped. All existence narrowed to the act of creating. I was one with all that ever was or ever would be. This little semblance of a pottery shop would become my refuge for several years to come.

Our small town lived practically in isolation during those days, but I didn't know that remoteness. Instead, my mind was busy imagining fascinating worlds of possibilities. I was forever seeking those kinetic moments, whether making little clay pots, exploring the mechanisms of my bicycle, or inventing an automatic kite flyer for my homemade kites.

Even at that early age, it was in those moments of creating when I felt most at home. There I found joy in just being.

After graduating high school, I entered Young Harris College, where the world of art and philosophical thought opened up to me. Even though the public school I attended

had offered nothing in the arts or philosophy, I had explored poetry, painting, music, photography, and, of course, my clay work pretty much on my own. Piano and guitar lessons were the exception.

But here in this small mountain college for the first time, I met a close group of people who loved discussing ideas, who wrote poetry, played music--people who were artists. In these folks lived an inner spark unlike that of anyone I'd ever known. For the first time in my life, I felt at home with other human beings, these students and teachers, whose zest for life felt to me like those childhood days in my pottery shop.

In this environment it was acceptable to question religion, to discuss philosophy, to look for meaning. Art was not just a hobby, art was life. And so it was here that I realized the arts as a calling. It was here that I turned toward painting and music and never looked back.

I became aware of the creative process as a concept in the early 1960s when, as a young teacher, I discovered Brewster Ghiselin's book entitled *The Creative Process*, which featured artists and thinkers of all genres, each recounting their experience with creating.

What I found intriguing was that no matter what the discipline or genre, the process of creating is universal. Ghiselin summarized what was to become for me a lifelong mission:

> the creative order, which is an extension of life, is not an elaboration of the established, but a movement beyond . . . to transcend the old order. . . . In order to invent one must yield to the indeterminate within.

As my artistic life and my teaching life unfolded, I became aware that the joy and exhilaration I had felt while a child working with clay was my inner spirit rejoicing in the act of creating. It became clear to me that my mission as artist was to stay in tune with and to hold true to that inner voice and that my job as teacher was to instill the same within my students.

I believe that each person is born with a unique way of seeing and can learn to express that uniqueness, that the teaching of art should be concerned with tapping this distinctiveness and providing techniques and knowledge to empower it to flourish. The creation of art should never be by imitation, but rather a manifestation of one's inner voice, the voice from one's individual uniqueness.

Finding Freedom to Create is a testament of what I have learned about how we artists can recognize and claim our own God-given individuality, and how we can best prepare ourselves to gain the freedom to make who we are the terms within which we create.

Because I am a painter and have spent my career teaching painting and drawing, much of what follows is written in the language of the painter. It is from here that I can speak with authority. Because I am also a musician, throughout these pages there are many correlations between visual art and music. And because I am a lover of poetry and the great mystics and philosophers, you'll find a thread from them as well.

CHAPTER 1

The Essence of Creative Freedom

Once you label me you negate me
—Søren Kierkegaard

Individual Uniqueness

To be free to create is to be unencumbered, to enter into the creative act without hesitation, without doubt, without self-consciousness. This haven is like a waterfall streaming in continuous harmony with an unending source and unlimited potential. Our supply of creative energy originates from within the essence of who we are, that place of uniqueness that comes with us the day we are born. It is our individuality.

This is the complete *I am* within each of us. From our birth moment forward, no matter what happens to us, we remain *I am*. Among the seven billion humans inhabiting the Earth, you are the only one among them who is you. You are your own creative source.

In a perfect world the *I am* would be given unconditional acceptance. The priority of the culture itself would be to nurture that distinctiveness, beginning at birth and continuing through full maturity. But societies are still evolving, still preferring that we blend together, still judging that to be acceptable is to be defined by externally prescribed collective values regardless of one internal identity. It is not a perfect world.

In most cultures, generation after generation tends to cling unquestioningly to accepted myths and beliefs. These they pass on to their children, just as their parents had to them.

They do not try to see the *I am* living in that little human being they were given.

From a very young age we learn either to appreciate who we are or to judge ourselves inadequate: it all depends upon the degree to which we feel we are acceptable. This dilemma seems familiar to many of us, especially those of us who as children didn't fit the expectations of our families or of the society and culture in which we grew up.

It is the nature of the artist to see things differently, to explore what other people take for granted. We imagine new worlds, we delight in small things others find insignificant, our strong intuition often leads us to ask questions that raise eyebrows, and our inner knowing sometimes defies conscious reasoning. Many of us perceive beyond what seems obvious or appears to be possible. We are most content when we are creating.

If we are fortunate enough to be born into a family that honors our quirks, we will grow a strong self-confidence, and our inner voice stands a good chance of becoming the driving force of our lives. But if our family insists on our putting aside childish things, replacing them with tradition's expectations, we begin to experience conflict.

As our world expands and as we continue to be exposed to the druthers of those around us, we begin to judge ourselves insufficient. We are conflicted between blending into the conventions of our culture or risking alienation. We need affirmation.

We find ways to camouflage ourselves in an effort to fit in. We convince ourselves that through imitation we can belong. We assume an identity that conforms with those around us. We take refuge in the shadows rather than embracing our uniqueness. *I am* goes into hiding. It becomes a matter of intention, preferring the safety of belonging to the security of being oneself. There is the fear of being alien within ones family and peers.

This pattern of imitation suppresses our inner voice, overriding it with the voices of our culture. Our individual

uniqueness becomes restrained and muted. It is from this place that we feel inadequate in our creative efforts.

Behind this camouflage we lack confidence in our own ideas, our spontaneity tightens up, we depend upon logic rather than our own intuition. We bombard ourselves with desires for approval from others, we search for ways to fit in, we try scheme after scheme, trend after trend. Our creative work becomes an elaboration of something that already exists, rather than a direct response from our inner artist. We tend to imitate styles, hitchhike on current trends, adopt accepted philosophies and theories, or else shy away from it all because we've convinced ourselves we can't do it—we're just not good enough.

Camouflage is no fun. It never stops bringing on conflict because it contradicts the truth of who we are. Maintaining camouflage causes a constant struggle that requires far too much energy. But just as the choice was made to assume camouflage, the choice can be made to emerge from it. This move makes a person feel shaky at first, but it gets easier day by day until, finally, it feels like home--because it is.

To live from one's individual uniqueness is to live freely. The motion is a perpetual spiral outward and upward. Rather than imitating whatever is already established, we are creating that which has never been. Rather than repeating, we are responding. Our creative lives are inspired and forward-looking, nonresisting, always learning, always exploring, always knowing that where we are is exactly where we belong.

Being free to create does not require a formulated theory or a set of rules to memorize and follow, nor does it necessitate learning a philosophy by which to live. It only requires that you learn your craft, learn how to compose with it, and respond from your own authenticity. That's it. That's all we need to do.

What I have learned as artist and as teacher is that there can never be full joy within imitation, and that the authentic artist can never be fully realized by limiting the self to acceptable

norms. There is no contentment to be found in camouflage. Real joy comes, in the words of American philosopher Joseph Campbell, by following your bliss. That bliss is ours when we follow the inner voice of our individual uniqueness.

Style: The Artist's Hand

Style is the artist's handwriting, the validation of the artist's inner voice. It is the distinct manner within which we shape our work, the outer manifestation recognized as our touch. Style evolves as the artist matures, but its essence remains consistent and always recognizable. True style is never faked or affected by imitation or elaboration.

When we first learned to shape letters of the alphabet, each of us was on our way to building a personal handwriting. It took a lot of concentration to create those letters, but by repeating the motions over and over, what began as a tedious task eventually became effortless. Ultimately we began to turn letters into words, words into sentences, and sentences into thoughts. The more words we learned, the more we expanded our ability to give nuance to what we wanted to write.

In time that skill became automatic. Our conscious thought now could concentrate on the ideas we wanted to express. We no longer had to think about forming characters and connecting words. We were free to communicate in our own handwriting.

As we matured and continued to practice, those around us recognized our writing as being unique to us. And as adults our signature became synonymous with our identity, legally and personally.

It's no different in painting and drawing. We develop our natural approach by doing. When we become adept in the mechanics of handling tools and materials, a visible consistency appears, our style, our artistic signature, emerges. When we trust this to what feels natural rather than attempting to imitate the trend or attitude of others, our style becomes our way of expressing our truth, our inner voice.

Our signature style should never be forced or imitated or contrived or anything but spontaneous. It should be allowed to develop instinctively within the journey of becoming artists. To affect our innate presence is to fake it, to distort the authentic process into something that is not our truth.

The beauty of allowing style to develop on its own is that one never has to wonder about it. Regardless of the genre, the work itself reflects the artist's true nature, whether working from observation, imagination, or abstraction. No matter how many artists choose a similar mode of expression, each utilizes a unique artistic handwriting, recognizable as that particular artist's style.

On a wall hang two unlabeled portraits, one by Andrew Wyeth and the other by John Singer Sargent. Each interprets his subject with a mastery of his craft. If we are familiar with the artists, we instantly know which artist created which painting. Even if we are not, it is easy to see the two styles as distinct.

As with these artists, your style comes from that inner self that is uniquely you. It is the signature of your individuality, which is unlike that of any other person. It comes from the place where your authenticity lives.

The question of style should not be a worry for the emerging artist. Listen intently to *I am* as your style automatically and spontaneously develops, becoming more refined as you mature as an artist.

The Creative Current

When we are fully immersed in the act of creating, there is a space within us where all that we are and all that we know come together into a oneness. We become so completely absorbed in what we are doing that we lose awareness of time and place. When we stay present there, not allowing ourselves to be distracted or to resist what is happening, we create freely and from wholeness. Here, we lose all self-consciousness: we are totally engaged in the act of doing. I call this experience

our *creative current*. It is the place within us from which we are free to create and, therefore, from which we grow and evolve.

Like an electrical current whose voltage flows across a wire, the creative current flows across an intuitive path that we access when we are totally focused within the act of creating, whether performing, composing, or constructing.

For centuries, philosophers have questioned why Shakespeare's works continue to sustain our interest, to excite and enchant us as if written yesterday. Why is it that so many works over the ages have succumbed to the dustbin of time while Leonardo's *Last Supper*, John Newton's *Amazing Grace*, Rodin's *The Shade*, Beethoven's *Fifth Symphony*, and so many other creative works continue to stand the test of time? Each is the product of an artist working in the creative current.

We see the creative current fully engaged when we watch a ballet dancer perform a perfect program, a golfer make an impeccable swing, or a pianist give a flawless recital. In each case, what is happening within the performer is a complete and mindful focus on the action: all control is yielded to the process where conscious thought about procedure is put aside, where all that happens comes from this wholeness of being and doing.

This is the place from which Tolkein wrote *Lord of the Rings*, from where Michelangelo carved *David*, and Mozart composed his *Requiem*. It is the arena from which the purest art an individual has to offer is made, from which arises the most effective expression of all that the artist knows and can do in that moment of creation. It is the place where the complete *I am* is totally engaged without restriction, without hesitation, without thought, without judgment. It is truly a state of being within which action flows. It is true consciousness.

Hungarian psychologist Mihaly Csikszentmihalyi coined the term *flow* to explain the activity of this experience. In his book *Flow: The Psychology of Optimal Experience*, he describes it as "the feeling when things are going well as an almost automatic, effortless, yet highly focused state of consciousness." Athletes call this being in *the zone*.

Flow as Csikszentmihalyi defines it alludes to what happens. My concept of *creative current* embraces his concept of flow but locates it within the field our intuition. Whereas *flow* points to what happens while we're directly engaged, the *creative current* gives that action an environment.

Think about that space for a moment. Imagine it as an actual location in your mind, an area that surrounds all that you know and have experienced being channeled through your act of doing, guided by your inner knowing. All you have learned and know how to do resides in that pathway and is always accessible to you. Whenever you go there for your creative experience, your activity automatically streams from that place and is propelled onward by the inner spirit that causes it to be alive and engaging.

Within that *creative current*, conscious thought becomes suspended in the moment. In fact, if logical thinking takes over, the performance will splinter, a misstep is likely to occur, or the creator will become sidetracked. We all have watched as a figure skater soars over a bed of ice, forming multiple configurations and movements, and we all know that sudden sick feeling we get when the skater takes a stumble and falls. The error occurred when the *creative current* was interrupted with conscious thought.

To stay within the current requires from us only two efforts: that our attention is given to the moment. and that our intention is our immediate action. It's a full-focused response to the *now*. When either force shifts to anything other than the process, the current becomes broken, thwarted, or fragmented.

After a successful stint of excellent pitching, Atlanta Braves pitcher Kris Medlen's work went into a slump. For several games in a row, his performance was mediocre and at times awkward. Medlen discovered that his problem had nothing to do with his skill, but came from overthinking: for every pitch, he had been assessing how the muscles in his body were moving, giving attention to how he was making the throw happen rather than to the pitch itself. Once he realized this, he refocused so that his attention was redirected to pitch itself,

allowing his body to react automatically. In his words, "I just relaxed and let it happen." His game improved dramatically.

Medlen's *creative current* was broken by his focusing on a logical sequence of moves he understood to be necessary to make a good pitch. He didn't need to do that, because he had practiced those motions so many times that his body automatically knew them. When he relaxed into that knowledge and let his intuition guide his pitches, he was back in business.

In fact, the *creative current* itself is guided by intuition, not by logical thinking. The role of what we know to be left-brain activity—rational thinking controlled by the left hemisphere of the brain—is for training and practicing, but has no part to play during performing. Amid the schooling and rehearsing of our skills, we build into memory the proficiency necessary to perform. When that awareness is guided by our intuition, the *creative current* is free to flow.

Tennis player Serena Williams, figure skater Kristi Yamaguchi, violinist Joshua Bell, and poet Maya Angelou all have one thing in common: each slides easily into the *creative current* and it is within that space from which they deliver their most astonishing work. It is when mastery of a craft actively unites with intuition that we see a person freely performing at their best.

The beauty of the *creative current* is that it is available at all levels of creating, whether one is a student just beginning to learn a craft or a master like those I've mentioned. We do exercises to learn new skills, and we practice them to hone our craft. When we've experienced enough practice that we can create without thinking, each new skill becomes an integral part of the path.

It is within *that* place that we have access to the *creative current*. Our performance aptitude gains momentum with every new thing we understand and learn how to do, causing the path to evolve in an upward spiral of creative motion. There is no limit to the magnitude that can be added to it.

It is my experience with this *creative current* that propels me to share with you a way of becoming prepared to keep the current open and flowing. Although I am talking to those who find their voice in the art of painting, the process is universal, regardless of one's mode of expression.

CHAPTER 2

Craft: The Artist's Voice

*Who you are gets defined in so many ways
that have nothing to do with you.*
—Wayne Dyer, PhD

There is a distinction between the *art of painting* and *craft of painting*. The *art* is the where ideas abide, while *craft* is the mechanics through which those concepts are expressed and made visible. *Craft* is the skilled motion that allows those new thoughts to be conveyed freely and with clarity. The two cannot function separately. Without substance no *craft* is needed, and without *craft* nothing can be communicated.

Craft begins to develop with the first mark the artist makes as a child. It involves developing muscle dexterity, learning how to use tools, grasping how to manipulate materials, and determining how to combine these skills to solve problems. In essence, *craft* is the how-to of any process. Its development gives the artist a voice, the strength of which is determined by the degree of competence acquired.

The outcome of anything we undertake to do is evidence of how adept we are at doing it. The richness, refinement, and depth of our work increase as we become more practiced in the mechanics: the more competent we are, the stronger our voice. In simpler words, the more we practice doing, the better we do it and the more confidence we have in our ability.

Art, then, is the expression of two voices: our inner voice from which we are motivated—our inspiration--and our outer voice, our *craft*.

The Decline of Craft

The craft of painting experienced a serious decline with the advent of Modernism in the early twentieth century. Out of this movement emerged the notion that to apply skill to the act of painting was to rob it of spontaneity, of innate innocence, and of creativity.

Students attending most art schools during the height of this trend were taught few if any painting techniques. In fact, they were assigned their materials and left to their own devices to figure out how to use them. Excellence in painting was judged in proportion to how inventive or original the artist's instructors and critics thought the artist's work to be. To some extent, in many colleges and universities this practice continues today.

Within these attitudes is the assumption that student artists can use their supplies without any instruction. The attitude is that they can learn to do this on their own, that no trained ability is required beyond knowing how to pick up a pencil and make a mark with it or load a paintbrush and slap paint onto a canvas. There is simply a disregard for teaching skills.

It is true that student artists most likely will have worked with art materials their entire lives. But to assume that they need no more mastery of their craft is to deny them access to an abundance of techniques both in drawing and in painting. It is a command of materials that takes out the guesswork and guarantees an artist dexterity to explore ideas without trying to figure out how to make them work. This absence of a command of skills will interrupt the creative current.

In essence what the Modernist era did was to rob emerging artists of an important element of the individual voice and replace it with a collective attitude of a movement itself. The ideals of the movement became the voice, completely bypassing that element of the individual's expression. It was the first time in human history that technical prowess was eliminated from the visual artist's repertoire.

Missing from the Modernist philosophy about painting is a simple fact: skill enables freedom to create. A painter can

learn the mechanics of drawing and of painting without losing an ounce of spontaneity or creativity and can do so without having to imitate another painter—a common falsehood used in defense of not teaching techniques. It is within our knowing how to do it that we are able to be spontaneous.

The Return of Craft

Concern for a return to acquiring techniques began to surface in the mid-1980s, thanks to the efforts of a few influential leaders like painter and teacher Richard Lack, whose classical training qualified him to set up Atelier Lack, a studio-school of fine art in Minneapolis. At first the school itself made a limited impression, but when Lack began publishing the *Classical Realism Quarterly* in 1985, an initial trickle of interest in reviving classical methods and *en plein air* painting burgeoned over the subsequent three decades. Ateliers and teaching studios, including my own,[1] began to surface throughout the United States and Europe.

Because of this movement, the craft of painting and drawing has seen a widespread revival, especially with the advent of workshops, how-to books, videos, and televised painting programs. Today art classes and workshops are a dime a dozen, and the market is virtually flooded with painting and drawing instruction in every medium, including on-line classes.

But there is a downside to this proliferation. Even though some of what is available is authentic and valuable to the learning process, there is among these myriad options a contingent that means well but lacks sufficient depth of knowledge and experience to convey a real idea and knowledge of craft. Consequently, too much of what is available today is based on practices that restrict creativity rather than providing substance to enable creativity to flourish.

[1] Dianne Mize Studio was launched in Clarkesville, GA in 1983 and continued for the next twenty-four years, having merged with the Sautee Nacoochee Center in 2000.

Restrictive Practices

Aspiring painters looking for instruction do so innocently. Thus they are vulnerable to being misguided by instructors who teach shortcuts for making paintings rather than the solid mechanics that facilitate the development of the artist's voice.

In this materialistic world, too much attention is given to the product and not nearly enough to the creative process, when it is the essence of the process unfolding that determines the quality of the product. Add to this the ego factor: self-exaltation among some personalities who are more interested in finding a following than in trying to help artists find their own voices. Consequently, a lot of what is offered today in the name of teaching is directed toward making paintings, not fostering the growth of artists.

To this end, many who want to cultivate their artistic skills end up being taught gimmicks that box them in instead of receiving solid skills necessary to enhance their own artistic voices. These shortcuts are aimed toward making paintings quickly. They are to craftsmanship what the microwave is to a chef. The focus is on the end product, not on the process.

From the student's point of view, it feels good to make a painting for which one can receive instant gratification and praise from family and friends. So students innocently latch onto those shortcuts without realizing the harm being done to their individual style of expression. That temporary feeling of success, though, is a dead end. It is in a sense microwave painting. The danger here is that it imposes upon the student limitations rather than empowering freedom. Within these approaches, there is little or no opportunity for the student's voice to emerge.

The flip side of this, and the one of which student artists might not be aware, is that paintings and drawings of a far higher quality result from a command of solid technical skills. Tricks and ploys do work to make pictures, but the outcome is bland compared to the richness that shows up when the inner voice of the artist is freed to be expressed through the outer voice of solid craftsmanship.

Emerging artists who want freedom to create rather than a quick-fix for making paintings would do well to avoid any teaching method that blocks them from the real artistic experience. Even though learning authentic skills might take a little more time, the payoff is the preservation of your own creative voice. Your creativity is your most precious inner resource, so you want to entrust it only to those who will empower its freedom.

Over the years, I have been involved in multiple arguments with instructors who employ what I call *restrictive practices*. My attitude toward these methods has evolved from what I have learned in doing my own artwork and what I have seen happen within my students' artistic growth in contrast to the results I have observed from instruction that I know uses these restrictive approaches.

Tracing Projections

One mode that directly demeans one's craft and stifles creative freedom is tracing projections. No other issue in the field of painting stimulates as much passion, anger, finger-pointing, and self-justification as that of tracing a projected photographic image as a layout for painting it.

We hear arguments that tracing is just one of the many tools available to artists, that it saves time and energy, that the grand masters of the past used similar available methods--all these in favor of projections.

Those against this practice argue that it is dishonest, deceiving the viewer by representing skills the artist does not own, and that it is not professional.

I offer you five more serious reasons why tracing projected photos is not good for the artist:

(1) Tracing is often a cover-up for not knowing how to draw freely.
(2) Tracing averts the freedom to explore the fundamental nature of the subject.

(3) Tracing denies opportunities to compose. Even if the photo being traced is well composed, and even if it was taken by the artist, tracing skips over and bypasses compositional insights. Images are locked in position, frozen.

(4) Tracing denies the artist the experience of making discoveries while drawing. Drawing enables one to invite and discover surprises that can greatly contribute to the freshness and life of a painting. Drawing might reveal an emphasis or a relationship of images that would otherwise go unnoticed.

(5) Tracing is self-deceiving and does nothing toward freeing the artist to create. Rather than give the liberation it promises, it makes the artist dependent, reinforcing any insecurity about drawing. Not only that, tracing makes the artist lie about skill: because the artist knows deep down that the work is traced, there is always a sense of having deceived, or tricked, the eyes of the viewer.

Perhaps the saddest outcome of tracing is that the artist is robbed of experiencing the wonder inherent in drawing. Instead, the artist reaches a conviction that drawing is laborious and something not worth to struggling with.

Where in the world did this last notion come from? Drawing is an exciting process of discovery and is the most liberating of all crafts to learn. Drawing trains the hand to follow what the eye is seeing. Just that. And it can be learned easily once a person sheds the belief that it can't be done. I demonstrate this in later on in this book.

Copying an Instructor's Work

A common instructional practice is to display one of the instructor's own paintings, then pace students step by step through copying it to reveal how the painting was made. But doing this, requires the student to climb into the instructor's

skin and be whoever the instructor was at the time that painting was done.

Instruction by imitation--a monkey-see, monkey-do approach--does two things to restrict freedom: it places the intention on the product rather than the learning process, and it clones the student's voice to the voice of the instructor. Students who learn only by duplicating are merely parroting instead of building skills toward independent self-expression and growth.

Years ago, there were a few televised painting instructors whose presentations were limited to showing viewers how to copy an already completed painting: "This is the painting we are going to learn how to do today." Happy little trees and stylized flowers permeated the air waves. That these instructors encouraged the audience with "You can do it" was not a negative thing: what was misleading was the method they encouraged. It is true that among their viewers, there were a few who leapt beyond the restrictions of copying, into finding elsewhere solid techniques toward drawing and painting. But too many accepted this copying method as their own. Looking at their paintings, a viewer would see exactly from whom they learned to paint.

We do learn initial skills by emulating movements. For example, I can show you how to create a gradation by teaching you how to hold the pencil, how to move it, and how to decrease the pressure gradually as you move it so that a gradation is created. Then by practicing that motion, you will refine and master the technique, making it your own. You will become so comfortable with how it works that you internalize it. As you continue to practice, you will do so within your own style, not mine. And you can use it wherever and whenever you need it. It has become an element of your own voice.

That is different from my showing you how to draw a tree. If I did that (and I wouldn't), you would put a version of that same tree into every drawing you make of a tree, thus echoing the image rather than using an acquired skill to interpret and express the uniqueness of whatever you see in the specific tree

you're viewing--its singular environment, the season, and the time of day.

If your learning experience is limited to how your instructor paints, your results will ditto that person's style. You will have become a clone of your instructor, limited to your instructor's style, and rather than expressing your own uniqueness, you will echo the person who taught you.

An Instructor Who "Corrects" Your Work

Something that I wish would *never* happen during a visual art lesson is for the instructor to make a "correction" on a student's work. Once that occurs, the work is no longer the student's. Even though that "correction" might have made the work look more acceptable, the student cannot in honesty sign it or even claim it because a portion of it--no matter how minute--was done by somebody else. But that's only a part of the problem.

The purpose of teaching is that something gets learned. If a guide shows you the way, you will likely know how to travel a path again on your own, but if you are a bystander while the leader treks, you've accomplished very little. The same is true learning to paint: if the instructor paints it for you, will you be able to solve a similar problem next time you encounter it? It is doubtful that you will.

A teacher would do well never to deny a student the opportunity to find a solution. By giving a demonstration-- showing options for ways to resolve a problem-- the instructor respects the student's work enough not to touch it, while allowing the student to learn something applicable to the next time a similar challenge is encountered. In fact, similar problems in the future most likely will be avoided.

Formulas

A formula is a restrictive method set within bounds that follow an established model. Examples of formulas in the drawing

and painting arena are how to draw a head, how to paint a flower petal, how to paint a rose, or any how-to that wraps a formula around an image rather than guiding you to look at the image and discover for yourself what is there for you to see.

A formula blocks your ability to see. It forces you, even though you are looking at a subject, to draw a preconception rather than what your eyes are actually observing. It interrupts your perception by substituting a pattern to be followed. Consequently, you never really see what lies before your eyes. Your vision has become filtered by some diagram you have memorized.

The irony of formulas is their promise to give you a way to create images without exertion while requiring mountains of memorization and cumbersome effort. The flip side of this is that once your hand learns to follow what your eyes are seeing, and once you acquire the technical skills, you don't have to remember a single thing: you can just relax and allow it to happen.

Using Another's Subject Matter

One of the most self-deluding and potentially illegal methods people use is to make a painting from someone else's photograph or artwork. This is a tricky issue. Often a teacher needs to have students work from the same image when showing them how to acquire a technique, but using a photo as a teaching tool is not the same as using it as if it were a person's original work. Classroom work is about practicing the use of techniques and ideas, not intended for creating original work.

The word "original" implies that the creation originates with its creator.

Keeping Your Own Voice

It is not my intention for this list of restrictive practices to be an attack on those who teach them. Rather, the aim is to

point out the limitations of these practices and the consequent inhibitions they impose on the student that block real freedom to create.

It really matters to me that every emerging artist becomes able to experience the joy and self-confidence attained from recognizing and claiming one's unique creative voice. My own schooling and five decades of teaching have convinced me that sound technical skills *are* the freeing agent to one's creativity.

During my years of teaching, among my most gratifying experiences was walking into a show of my students' work and seeing the diversity of individual voices on display. By the time students were in their second or third quarter of study, you could recognize each individual's work from across the gallery. Nobody wants to be denied such an opportunity for self-actualization.

CHAPTER 3

Seeing: The Artist's Resource

*And suddenly you know: It's time to start something
new and trust the magic of beginnings.*
—Meister Eckhart

Why is it that so many artists think drawing is difficult, yet they can set up their easels *en plein air* and make beautiful paintings? Why draw anyway? What is drawing?

Drawing is the purest form of seeing. It is letting go of expectations, preconceptions, judgments, and fears and giving our eyes permission to do their job while guiding our hand uncensored. We take nothing to the subject except curiosity. We go to it directly as-it-is without any intention other than knowing it. We feel the subject. We become the subject. And when a drawing is done, we have tangible proof of a real experience.

Drawing is *not* copying what our eyes are seeing. To copy is to replicate or imitate or reproduce. In real drawing nothing is replicated, nothing is imitated, nothing is reproduced. On the contrary, the act of drawing is conveying a response. We, the acute observers, explore a subject and as we do so we transmit onto paper our findings.

In real drawing we are not *trying* to draw. When you sign a check, you don't *try* to make a signature: you just do it. When you chew your food, you don't *try*: it's an automatic action. When you turn on a water faucet, you don't *try*: you just make it happen without thought. Real drawing comes from the same lack of effort.

Authentic drawing sidesteps thinking. Thoughts are not seeing. Deliberating about what you think you should be seeing distorts perception and contaminates awareness.

With the proliferation of coloring books and other reproduced images intended for children to "fill in," we grow up with preset notions of how images are supposed to look. The culture takes on misconceptions that an artist's role is to make copies, but the inner artist copies nothing. The inner artist observes, translates, and imparts.

A young man wanting his portrait painted assumes that the artist is going to reproduce his image, preserving it for posterity. But when the inner artist is really at work, a portrait will be a translation of what the artist sees, not a reproduction. The artist has conveyed, not duplicated. And here's where we must discern the disparity.

It is the notion that we must reproduce what we see that misleads an artist to believe that drawing is laborious and intimidating. If we think we have to duplicate something, tightness gathers within us. We recoil. Fears about our inability to replicate intimidate us to the core. We think we are being expected to recreate a two-dimensional exactitude of a three-dimensional world. This is all wrong.

We can correct this by retooling our brains to define the act of drawing as transmitting a response. Think of the mechanics of this: The eye's retina relays the artist's awareness to the hand, and the hand transfers the awareness to paper. This is drawing. This is seeing.

Drawing is not something that has to be memorized. It requires no rules. No special tools are needed. It can happen on a dinner napkin, the back of a grocery list, or in a sand pile. It is an allowing. It is erasing all the voices of expectation. It is anticipating nothing. It is bypassing all the garbage gathered in the reservoir of belief and letting happen a simple act of responding.

Responding is putting your arms around a child who wishes you happy birthday. Responding is laughing at a joke, sneezing from a nose tickle, dancing to a jazzy rhythm, looking up when you hear ducks flying south. Drawing is responding

with the same spontaneity as hugging-laughing-sneezing-dancing-looking up.

When your hand is following what your eye is seeing, there is no right way or wrong way. You are simply allowing your eye to take in whatever it is gazing at, to discern it as it is. When your hand follows that, it is responding to the *what is*. There are no rules about how you see it. There are no expectations for how you reply to it. There are no fears of getting it "right." You just see the *what is* and acknowledge that it is there. There is no correct way for the *what is* to look, or for you to look at it. You just answer to the *what is* as it is. This is drawing.

Let's Draw

The Air Glide Exercise

Take a trip with me. From where you are right now, look a few feet ahead, at whatever might be in front of you. Close one eye, hold your arm straight out and point your index finger at any edge of the thing you are looking at. Keep your eye and your finger aimed at the same spot. Take a deep breath (this is important), then with your eye following your finger, glide your finger along that edge, then along the next edge, then the next, continuing until you've moved along every edge you see.

Travel over whatever edges appear, large and small, inside and outside. If you see edges not connected to the original one, glide right over to the new edge and keep going until all the edges you detect have been visited.

Now, stretch your shoulders, arms and hands, then relax your arm, close both eyes and take a deep breath (again, this is important). Look at that object again. What do you see now, that you did not notice when you first looked at your subject? What did you discover while you were taking the trip?

What you have just done is to explore that thing you are looking at without expectation, preconception, judgment, or fear. You responded. You drew.

Let's try adding something to this experience.

The Phantom Drawing Exercise

There is no right or wrong way to do this. Just relax and experience what happens. Play with it.

You'll need a smooth surface no smaller in dimension than 10 by 15 inches. Even a cutting board or cookie sheet will work. We'll call it the phantom board.

Sitting down, prop the board vertically on your thigh a couple of inches above your bended knee. Steady it with your nondominant hand. Once your board is ready, select a subject. Whatever is in your view will do.

Take a long, deep breath (yes, again). Close your eyes, now gently move your dominant hand's fingertips over the surface of the phantom board. Feel its size—top, bottom, right, left, and center. Open your eyes when you have made a comfortable acquaintance with the board's surface.

Look at your subject. Do the Air Glide exercise. Breathe deeply.

Close your eyes. Gently move your fingertips over the phantom board's surface while you imagine onto that space how the Air Glide image will fit within it. Open your eyes and take three really deep, slow breaths.

Now, you're going to transfer the Air Glide exercise onto the phantom board. Here's how: All the movements will be the same. Your eye will move along all the edges of the subject and your index finger will *follow those movements,* but over the surface of the phantom board rather than in the air. Keep your eye on the subject and you mind on breathing.

Yes, if you followed these two exercises, you were truly seeing, and you were drawing. You do not have a record of what you did, but you undeniably have the experience. You are not likely to judge or cringe at what your hand created. Nobody else will see what you just did, so you are not subject to anyone's judgment or sneers or eyeballs rolling. Isn't that what holds you back? Isn't it a fear of being judged? Even of judging yourself?

People apologize for not being able to draw. They seem intimidated by the act itself. How many times have I heard someone say, "I can't draw a straight line!" Oh, really? If you ever jotted down the numeral one, you drew a straight line, so what's *that* all about? In fact, every time you write, you are drawing shapes of letters. How did you learn to do that?

If you did the Air Glide, you proved you can draw. If you did the Phantom Drawing, you reinforced what I already knew, which is this: if you want to draw, you can. These two exercises practiced again and again can give you confidence that you can do it without any effort at all.

The beauty of this approach is that it allows you the freedom to experience whatever subject interests you. Let's enhance this with one more adventure.

The Cruising Exercise

For this, all you need is either a sketchbook or a sheet of paper attached to your board, a mechanical pencil or sharpened office pencil, and one of your favorite shoes. Place the shoe so that you can look at it without craning your neck.

Situate your paper so that you can comfortably make marks on it and hold your pencil the way you normally do for writing, with *one minor change:* allow your index finger to extend along the barrel of the pencil, aimed at the pencil's point. This is to encourage your entire hand to guide the pencil, rather than having the fingers press in and manipulate the pencil as you would with a writing grip.

You will need some practice time for this new grip to become comfortable, so just scribble for awhile. You will notice that extending the index finger not only involves the hand as a whole but causes a lot of arm movement. That helps release your muscles to translate more freely what your eye is seeing into marks that you create on your surface.

Remember that there are three major activities in play, here. Your eye is guiding, your hand is following the eye's lead, and (don't forget!) your mind is focused on breathing. All

these exercises have reminded you. again and again, to take a deep breath, or several, as part of the process. Doing so at the beginning and end of a drawing, then keeping awareness on your normal breathing while doing the drawing, helps you relax and sharpens your acuity. If your mind is on breathing, you prevent yourself from overthinking. You may be surprised at first to notice that, all too often, you find yourself holding your breath, as if trying too hard to concentrate. With practice, this too will relax.

Thinking slows down your drawing, impeding the eye's ability to see by telling it *what* it is seeing instead of letting it do its job. By keeping your mind occupied with observing your breathing, you stay more relaxed and prevent your mind from meddling in the affairs of your eye.

Now, on with the Cruising Exercise. Do not rush this. Give yourself adequate time to get comfortable with your new grip. Practice keeping your mind on breathing while you doodle around on paper. Take as much time as you need.

Then, when you feel ready, with your new grip, use the pencil point while you do an Air Glide over your shoe, following its edges as if with your index finger as you did with gesture in the original exercise. Remember: mind on breathing, eye on the subject, pencil point in hand following the eye.

When the Air Glide is finished, move your hand to the paper's surface and do the Phantom Drawing exercise, *with a slight variation:* you are holding the pencil now, not touching the paper yet, but hovering just above it. Your lower fingertips will touch and feel surface while your thumb and index finger hold your pencil. Gradually, the pencil point is replacing the role your index finger played in the earlier exercises.

Keep your mind on breathing.

Next, the Phantom Drawing transforms into Cruising. Everything remains the same except the point of the pencil is now doing what your index finger did earlier.

First, take a deep breath. Then feel how the shoe will fit onto the paper. Breathe again. Then start the drawing. The pencil tip on the paper will cruise around all the edges of your shoe

Make this a smooth cruise, like a ship sailing on smooth water, without any hesitation. Keep your mind on breathing. Let your eyes do the guiding and your hand do the following. Keep your eyes on the shoe, not on the paper. Feel the hand moving. You will actually sense the shape of the shoe. You will realize how it's fitting onto the paper. This is how people without sight find their way around.

You don't want to go off course, but you will if you look at the paper. Keep cruising right along, feeling the hand moving in answer to what your eyes are finding, until you have sailed around all the edges of your shoe. Before looking at the drawing, close your eyes and take a long, deep breath.

How to Look at Your Drawing

The most crucial part of your experience at this point is what you allow yourself to see when you finally look at your drawing. The immediate tendency is to judge whether the drawing looks like a shoe. But, no, that's the wrong way to proceed. And yes, at this point there is a right way and a wrong way.

Look instead for how relaxed your lines are, for how freely they flow on the paper, for where they got darker or lighter, heavier or more tentative—and look for the presence of shoeness. Now is not the time to judge for conventional accuracy. That is not what drawing is about. In fact, it is in error to judge at all. Noticing evidence of the experience is the only way to look at a drawing. Criticism of any sort is totally irrelevant and harmful. The only thing to be evaluated is how free you were when you did the drawing.

If this was your first drawing experience, you might have been a bit nervous about it. That's okay. I was nervous the first time I put on a pair of skates. And I busted my bum a few times before I could allow those skates to take me for a cruise. So what? Bust your bum a few times, but my promise to you is that if you practice this set of exercises—the Air Glide, Phantom Drawing and the Cruising Exercise—again and again with all sorts of subjects, you will free yourself to draw.

Your attitude about drawing will be totally revolutionized. And you will forever see the world in a new way. If you do no more with drawing than taking these exercises and making them your own, doors will open that you never could have imagined.

Oh, by the way: I just taught you how to do contour drawing, and there was a bit of meditation in there, too.

Seeing as Your Resource

By now you've got it. You have experienced that seeing is not what your mind tells you is there, but what your eyes register. The more your eyes have an opportunity to roam, the more they see—the more *you* see.

There is so much to see, and there are so many ways to interpret what you see. If you would like to delve deeper, Kimon Nicolaides' *The Natural Way to Draw* is an invaluable and solid program of instruction. But if you would prefer something on the lighter side, try Betty Edwards's *Drawing on the Right Side of the Brain.* And *Zen Seeing, Zen Drawing* by Frederick Franck demonstrates unsurpassed insight into getting your hand to follow what your eye is seeing. For a variety of drawing techniques, Bert Dodson's *Keys to Drawing* is brilliant.

I am convinced that seeing through drawing is the most relevant of all means toward finding creative freedom for the visual artist. The irony is that along the way from toddler to adulthood, too many of us have been stifled into believing we can't draw. It seems almost as if our culture wants to make absolutely sure we don't retain that open-eyed innocence we had as children, that curiosity for finding how we see what's there rather than rationalizing what should be there, that joy of exploring rather than being boxed in by attitudes of others.

But I am equally convinced that any person who genuinely wants to reclaim that innocence can do so, that anybody who has a deep desire to draw not only can, but will.

The visual artist's resource is seeing, being alert and awake, noticing and perceiving, inspecting and surveying, being conscious. Not only a mode of expression, drawing is also our initial note-taking skill for all the elements of the artist's resource. But there is another kind of seeing equally important: how we visually assemble our images, what we do with them in the long run. That kind of seeing is called composing.

CHAPTER 4

Composing: The Heartbeat of Expression

There are a thousand ways to kneel and kiss the earth.
—Rumi

Why compose? Why not just spit forth an art work in its purest form and let it be? Why not allow the intensity of experience pour out expression in blatant innocence? Why not let inspiration explode untamed, uncontrolled, uncontaminated? All of these can happen composed or uncomposed. To which of those would you gravitate? With which would you want to live? Which would you want to experience more than once, over and over again?

Art is about human spirit touching others through a universal law of energy that lifts one up, that opens awareness into wholeness. Art in its truest meaning cannot be destructive, fragmented, erratic, aimless, or stagnant. Art is an outward and manifested expression ordered according to an inner response to experience. That ordering, which is the act of composing, is what makes the expression comprehensible, buffering it enough to be receivable without sacrificing its stimulation. Expression without the composing is mere purging.

The creative mind is born knowing how to compose, and when that knowing is allowed to unfold, it gives life to everything the artist creates. Just as without the need for a musical score a musician can play by ear a tune overheard in passing, the visual artist has an intuitive ability to arrange and build a visual composition.

So, why study composing? If we already know how to compose, isn't it redundant to study it? Our intuitive gifts are a door through which we enter the world of creating, an entrance that invites us to augment our knowing with greater understanding and a broader reach into all that is possible. Familiarizing ourselves with the natural laws of cause and effect, we can construct our visual pieces with an ease and inventiveness that otherwise we might have to struggle to achieve.

Visual artists, musicians, writers, and even athletes soon realize that optimal performance requires an expanded awareness of everything related to their chosen fields of endeavor, and of how those interrelationships work. That is, the more we know, the more effectively we can express our gifts. One person may write a thousand-page thesis without conveying a single idea, but another can gain the attention of millions with a simple parable. Neither the volume nor the length or the size or even the content of a work determines its effectiveness. The impact lies in how it is presented.

Music that we listen to repeatedly, paintings we keep going back to, poems we read again and again—these would not get a second notice exclusively for their content. It is *how* the thought is transported that most strongly influences how it is received.

For the visual artist, that carrier is composing, how visual expression is put together and how it is produced. There's no mystery to it at all. Composing is just how the visual artist chooses to assemble the parts. the components, of any particular piece.

And that is what makes composing the heartbeat of expression. It is the pathway through which artistic inspiration becomes woven into a creation, making it both accessible and magnetic. It is the life force of every work of art.

The Means Is the Messenger

But what is there about knowing how to compose that gives an artist freedom to create? What is the connection between this freedom and a well composed painting?

As with craft, the freedom we find in composing comes with the power of knowing what to do. We make ourselves aware of how composing works, and we also channel that knowledge to make the work say what we want it to say without a struggle. We become so acquainted with our knowledge that we do not have to think about it while we are working. It becomes a part of every move we make, of how we see and how we make our decisions.

It is not by accident that the visual path extends from Christina toward her house in Andrew Wyeth's *Christina's World*. It not by happenstance that the tension is set and enough harmony is added for us to bear looking at Edvard Munch's *The Scream*, or that tumbling is converted into rhythm in Marcel Duchamp's *Nude Descending a Staircase, No. 2*, or that fragments resulting from violence are assembled into unity in Picasso's *Guernica*.

Whether it is the contrast of lights against darks that gives depth of expression to Rembrandt's self portraits, or whether it is the value gradation that creates the realism in Michael Parke's *Tuesday's Child*, or the modulation of shapes Cezanne uses in *The Card Players* series, how the artists composed is the conduit for how these effects achieve their ultimate meaning.

Whether contrasting colors, overlapping shapes, blending values, or leaving out details, the choice is an act of composing. The economy of images in Winslow Homer's seascapes, the elaboration of movement in Inka Essenhigh's *Spring*, the dominance of green in Claude Monet's 1899 *Pond of Waterlilies*—these were set in motion with composing.

The means, the composing, is the messenger.

Born Knowing

But it goes deeper than the message. We intuitively know that life in chaos must be returned to some semblance of *order* for us to stay sane, that life fragmented cannot carry on without *unity*, that instability in life will cause us to die if not brought into *balance*, that without *harmony* total discord

will render us nonfunctional, that things go haywire when thrown out of *rhythm*, that things stagnate without *movement* and that *proportion* undergirds it all: too much of anything is overkill, too little may be death. These things are the essence of composing. To be composed holistically means that order, unity, balance, harmony, rhythm, movement, and proportion are functioning optimally.

Nature itself depends upon these conditions. We live with them every day. We know them as well as we know our own image in a mirror. They are in the very heart of our wellbeing.

The beauty of composing is that we can express chaos and confusion by giving to the structure enough order that the communication can be received. We can express fragmentation and brokenness within a context of unity. We can convey instability within a balanced format. We can show discord within a harmonious color field, we can translate awkwardness and the erratic within a rhythmic organization. We can show aimlessness and stagnation with visual movement. We can display excess through variations on proportion.

And we can convey order without being staid. We can evoke unity without dogma. We can explore balance without inflexibility. We can awaken harmony while retaining vibrancy. We can forge rhythm without suppressing spontaneity. We can organize movement without dictating. We can evoke proportion without stifling creative energy.

Within the realm of composing there are no limits, rather only possibilities. When we live it rather than trying to induce it, we find within each of these living laws infinite possibilities. It is not a matter of memorizing and applying, but internalizing and experiencing.

Demystifying the "Principles" of Composition

Unfortunately, though, composing has been given a bad rap in modern times: these laws of physics that make everything in the universe work, when applied to art, have been mistakenly construed by too many artists as restrictive rules, to be resisted.

Many other artists are scared of breaking any of these rules, almost as if they were holy writ. Either that, or perhaps because of that, they all decide they want nothing to do with what they interpret as that degree of constraint.

I am referring here to that dreaded notion, *principles of composition*.[2] Critics and art historians love to pontificate about them, not surprisingly, because cerebral types enjoy heavy concepts. But freer spirits may too easily deplore these principles, fearing that burdensome thinking will weigh down creative expression.

I have concluded that a big part of the problem lies with the word *principles*, a term that has come to imply either staid dogma or intellectual elitism. The word itself suggests that there is a code to memorize, then devoutly to be followed. It sounds restrictive and stifling, evoking restraint on all spontaneity.

What the word *principle* denotes to us staves off any enthusiasm to explore what lies behind the façade. But in fact the *principles of composition* are simply the laws of nature that generate energy. They are not strict regulations, as some would have us believe, but active forces that sustain everything we do. They are the conduit of life itself.

These players are the engine that makes a painting work, energy that drives stimulating discoveries and unique expressions with unlimited potential for opening up new options. When fully functioning within of the artist's skills, they fuel freedom rather than imposing restriction, because it is within their realm that we know what to do to give to our work our optimal expression. And when we know what to do, we are free to find new ways to do it.

A New Name, A New Way of Thinking

So let's change the language. Let's put aside the word *principles*. Let's replace it with a word that is active, with something not carrying any baggage, something that tells us what these forces

[2] Also called *design principles*.

do, that implies life itself. Let's call these operatives *composing generators.*

Yes, I'm exerting my creative freedom here by changing the terms: I'm changing the jargon. I'm deconsecrating the holy grail of visual parlance by renaming it according to the life it gives. I'm replacing the attitude of *what should be* with *what can be.*

The Composing Generators

We can bring these generators into our consciousness and realize that we already know them. We can take them one at a time and rediscover how they function. We can learn ways in which artists and scientists of the past have expanded them, and find for ourselves new ways to make them work for us.

Think about this for a moment. Learning a new device begins with a conscious effort. Take, for example, a smartphone. First you discover the basics of what makes it work, then you practice the procedures until using the phone becomes second nature. The first encounter is awkward, but the more time you spend with the phone, the more automatic the interaction becomes. Eventually that text message just happens with no conscious effort.

Our generators work for us the same way. Regardless of the whether an artist has mastered painting craft or is just beginning to learn it, if some practice time is devoted to giving the generators a real workout, taking them one at a time and approaching each with the same attitude as learning how to use a smartphone, one by one the generators become a part of our collection of gadgets, accessible when needed without requiring any conscious thought. Their value lies in our comprehending how they work within all that we know. In fact, we come to realize that we really knew that from the beginning.

Even more intriguing is how all these work in concert. As we take a look at them individually in the next chapters, you will notice this collaboration over and over again.

Generators' Roles

In painting, we use two kinds of composing generators: those that do the work and those that result from the work having been done. One way to think about these roles is to compare them with baking bread. Flour, yeast, water, oil, sugar, salt and heat each play a distinctive role when combined together. We could call these ingredients *workers* and the bread the *results* of what these *workers* do.

When composing, the *worker generators* are always busy making the *results generators* happen. They play their roles while the work is being created and continue being active for as long as the work endures.

They are not like a paint brush that the artist uses but the viewer never sees. Once put into action, the composing generators remain alive, functioning perpetually, always present, constantly operating. Just like our physical bodies, they will stop working only if the painting ceases to exist.

CHAPTER 5

How Composing Works

Our task must be to free ourselves from this prison by widening our circle of compassion to embrace... the whole of nature in its beauty.
—Albert Einstein

This and the chapter following are about how these powerful players, the generators, function as we compose our paintings. I look at the *results generators—order, unity, harmony, rhythm, movement, proportion*—first, because they are the essence of our target. In fact, any one of them could be what the painting is all about.

I follow with the *worker generators* because how we use them creates those *results* of order, unity, harmony, rhythm, movement, and proportion.

Then I explore how visual language functions, because without it, the *worker generators* would have nothing with which to do their jobs.

These two chapters are given to you as a reference, as the best way I know to explore with you the guts of the matter. It is not my intention to imply that these generators should be memorized, rather that each emerging artist might become aware of how these things function. It takes only an awareness to begin to pay attention to how something works.

The Results Generators

Order
Unity
Harmony
Balance
Rhythm
Movement
Proportion

Order *and* Unity

The opposite of *order* is chaos. Chaos is clutter, the debris of fragmentation. We experience chaos when riots break out or a tornado hits a community. Whether among humans or within nature, to survive chaos things must be sorted into some semblance of *order*, they must be put back together into a functioning arrangement or pattern. Lying between *order* and chaos is muddle, a place of ambiguity where stuff gets vague.

I remember as a kid being overwhelmed by opening a box of jigsaw puzzle pieces. There was a picture on the box of what the puzzle would look like once assembled, but what was inside were hundreds of little squiggly shapes lying in a meaningless heap of total bedlam.

My first task was to turn them all face up. Next was to sort them into similar colors, then to find the four corner pieces and then those having a straight edge, because these composed the sides of the picture. Each of these steps was moving toward giving *order* to chaos. One by one, I would find the pieces that fit together, and eventually they all would find their places to complete the picture. Once *order* was restored, all the pieces fit to form the total picture giving it *unity*.

The opposite of *unity* is fragmentation, that splintering off and shattering away that destroys wholeness. In life and in art, to fragment is to separate away, to break apart from the whole, to crumble bit by bit into incompleteness.

Another way to say this is that *order* is how things are put together and *unity* is the oneness created when each piece belongs to a whole.

Harmony

Nothing grates on the human nervous system like a cacophony, a clashing of harsh sounds or the tension of naysayers in a consensus-building discussion. Where there is an abundance of discord, there can be no order or unity until *harmony* is restored. *Harmony* means that everything is in accord, in tune.

Have you ever been in a place where you could hear two pieces of music coming from separate directions, each being played in a different key? That is the opposite of *harmony*. In an orchestra, if one of the violins is out of tune, it throws an unpleasant dissonance into the entire piece being played. And one of the worst ear-assaults is a piano so out of tune that no matter how masterful the pianist, the music is nerve-racking.

Harmony is kinship, a feeling of elements being in accord, an overall sense of agreement among the components of order and unity. In a community of people, there is a degree of like-mindedness that keeps the group unified.

In visual art *harmony* is created by at least one single element of consistency—a similarity in shape, or overall color temperature, or repetition of movement, for example. *Harmony* is felt through our senses whereas unity and order are more rational by nature.

Balance

When I was growing up in rural north Georgia, we made our own see-saws with a long board set across a wooden sawhorse. Two kids, one on either end of the board, and we were off for a fun ride unless one kid was a lot heavier. In that case the lighter-weight kid got a higher ride and had a lot more fun. We knew instinctively that the see-saw would not *balance* if we did

not adjust the location of the board on the sawhorse according to the difference in the riders' weights.

Balance is equilibrium of opposing forces. If we are physically thrown off *balance*, we will fall. If our psyche is thrown off *balance*, we become an emotional wreck. No *order*, *unity* or *harmony* can exist without *balance*. It is the necessary force to facilitate our ability to comprehend and discern so that we can perceive and appreciate.

One interesting characteristic of *balance* is that it can be achieved horizontally, vertically, diagonally, or spherically. It is a directional force that equalizes the pull of opposites. What's remarkable is that stability can be restored by adding a bit of the opposite force, as children on a see-saw might add a heavy backpack or rock to the board to equalize their different body weights. Similarly, a falling man can regain his feet if he is pulled in the reverse direction.

Rhythm

All life is energy in consistent flowing motion, a *rhythm*. If that pulse is interrupted, thrown out of its cadence, chaos ensues. Consequently, for there to be *order, unity, harmony* and *balance*, *rhythm* is essential.

Our hearts beat in *rhythm*, cycles of nature sequence in *rhythm*, the engine of your car alternates in *rhythm*, we walk in *rhythm*, speak in *rhythm*, breath in *rhythm*. Life depends upon *rhythm*.

All *rhythms* cause patterns created by repetitions and variations. But if a pattern becomes irregular or becomes erratic or static, there arises a probability of either overexuberance or death.

Rhythm implies living flow without interruption. It is from within the *rhythm* of creating that we enter into the *creative current* from which whatever we are doing streams effortlessly, a place where time stands still while we soar within that space of continuous, undisturbed beatitude.

Movement

I grew up in a little village that had footpaths. One path led to town, another down to Aunt Alice's house, another through the fields to Miss Inez, who gave guitar lessons. The paths were as communal as highways, and even though some went right through neighbors' yards, nobody made a fuss. Everybody knew the paths, and most folks followed them. They provided the whole community with a course for moving to all destinations.

Movement implies energy, that which constitutes the entire universe. Energy without direction or pattern is chaotic, but when ordered into comprehensible motion, something that we can maneuver through, within, and around, it enables us to share our experience. With the force of *movement*, we can be path makers.

Nature abounds with subjects worth painting, but if we jam too much stuff into a painting willy-nilly, our viewers will not know where to look. It is like throwing them into a wilderness with no way out. But just as a composer of music guides what we hear, note by note and chord by chord, painters can guide how the viewer sees by creating visual paths. And these passageways can enrich a painting, helping sustain viewers' attention.

These paths can be planned ahead of time, worked in during the painting process, added at the finish, or any combination of these. In most cases clues to their placement will be found in the subject matter. But if no path for the eye is present, the eye gets stuck or becomes confused, or wanders off without seeing the entire painting.

Later, I outline several classic paths that have emerged throughout the history of painting. Artists find ways to combine these classic paths, to vary them, and to elaborate on them. Often, though, an artist will create a unique path effective in its own right. Whatever works to keep the eye moving throughout the painting will become a visual path.

Experiencing *movement* in a painting is like following a melody line or feeling a chord progression in music, pulling us from one area to another before we come back to the tonic chord. Without it, everything stops in stagnation. If the path is not clear, the result is aimlessness.

Just as during my childhood, those paths took us to where we wanted to go, the paths we create in our paintings will guide our viewers throughout the piece, holding their attention while giving them routes in which to roam.

Proportion

We use the language of *proportion* every day. Not enough of this, too much of that: it's written in our DNA.

We knows the claustrophobic feeling of walking into a small room containing too many pieces of oversized furniture, or of entering a large, empty hallway where we feel intimidated by the vastness of the space. Even worse is dumping a cupful of salt into the cookie dough rather than the sugar we intended. Keeping things in *proportion* is a real, consequential activity.

Proportion is "a relationship between things or parts of things with respect to comparative magnitude, quantity, or degree."[3] In our lives an excess of anything can either inundate us or bore us to tears. We may be overwhelmed by chaos, fragmentation, discord, instability, and inconsistency, or we may become bored by too much sameness, too little activity, or a lack of stimulation. *Unity, order, harmony, balance, movement,* and *rhythm* all depend upon *proportion* to keep them alive and active.

In fact, *proportion* is most likely the key factor within all the *results generators* because it determines capacity, dimension, the scope and relationship of all the others.

[3] Definition is from freedictionary.com

Results Generators Continuum

Optimal Functioning		Nonfunctioning
Order	Muddle	*Chaos*
Unity	Puzzling	*Fragmentation*
Balance	Wavering	*Instability*
Harmony	Noise	*Discord*
Rhythm	Awkwardness	*Erratic*
Movement	Aimlessness	*Stagnation*
Proportion	Unevenness	*Overkill*

The Magic Continuum

Keeping a painting fresh and stimulating without letting it get out of control is a challenge that keeps artists on their toes. While it is important to comprehend the seven *results generators*, it is equally vital to remember that any one of them taken to extreme can stifle the life out of an artwork. To avoid this, keep in mind the continuum between each and its counterpart. The most interesting art since the time of cave painting is that which finds its *results generators* working within the continuum rather than at its extreme.

For example, *order* needs pattern that is sufficiently relaxed that its effect will not be stiff, overly structured, or stifling. *Unity* calls for wholeness without total perfection. *Balance* asks for equilibrium with a bit of tension. *Harmony* wants consistency with enough dissonance for stimulation. *Rhythm* requires pulse and cadence with an occasional surprise. *Movement* introduces motion without speeding out of control. *Proportion* requires a considered degree of all these modulations.

The point is to relax with these *results generators*. Artists make the best use of them by becoming conscious of their presence as the work evolves, without focusing on them directly.

The Worker Generators

Any construction job has work crews, each responsible for a specific element of the building. There are the carpenters, electricians, plumbers, painters, landscapers, and many more. Each plays an integral role, but all must cooperate as a team or problems will soon arise.

Composing a painting works the same way. Each generator contributes to the outcomes just discussed, yet all work in concert toward giving vibrant *form* to the painting, a form that communicates the intention of its creator.

This *form* is a painting's wholeness. It is the consequence of how the parts are assembled. The work becomes accessible. The viewer can mentally capture what has been done. Another way to say this is that when the *results generators* have been successfully built by the *worker generators*, the painting will be complete.

The Worker Generators

<div align="center">

Selecting and Placing
Contrasting
Emphasizing
Transitioning
Repeating and Varying
Elaborating and Economizing
Isolating
Overlapping
Converging
Assigning Dominance

</div>

Selecting and Placing

Selecting and *placing* are our first acts of creating. *Selecting* comes first and begins when something captures your attention and calls you to make it a subject of painting. Some people call this inspiration. For others, it's called noticing or paying attention.

Placing comes next when you begin to set perimeters, when you made decisions about how you will narrow down the entirety of whatever caught your attention.

For example, the buzz of a busy street includes all the architecture, cars, people, and traffic lights. If the *movement* of the people catches your attention, you've begun to make a *selection*. When you frame a group of those people within the context of a few store fronts, you are *placing* perimeters around them, you are narrowing your subject.

The *selecting* and *placing* action continues to repeat and refine itself over and over again, until finally you've decided what of this subject will get placed where on the painting surface. You could photograph the subject from many angles, you may scan the scene through a viewfinder,[4] or you might do some quick thumbnail sketches to play around with the idea. Artists work this part of the process in a variety of ways.

Once it all gets narrowed down, we *place* the images on the painting surface in a way that will best express our sensitivity about them. Within a rectangle or square,[5] a tension is already present between the edges of the surface. Being adroit as to where images get placed within that enclosed area determines the dynamics of the painting.

Artists have learned, for example, that when arranging images, certain areas of a rectangle have a strong potential for being aesthetically dynamic and invite the viewer's attention. The discovery of these areas grew out of artists' familiarity with the Golden Ratio.

[4] A rectangular opening cut into a small piece of cardboard or created by touching the tip of your forefinger to the tip of your thumb. Like a camera's optical viewfinder, it frames views to enable choices for selection.

[5] As opposed to a circle or oval, where the outside edge is a continuous line; or as opposed to an unconventionally shaped surface with more than four edges.

Golden Ratio

The Golden Ratio[6], was used by the Greeks beginning around 400 B.C and it is suspected that the Egyptians used the principle to design the pyramids long before that. It is a *proportion* ratio from length to width of 1 to 1.618. It can be found in growth patterns within plants, sea creatures, the human body, microscopic cells and the entire universe. It is so effective that in addition to the visual arts, it is used in music, in science, in mathematics, and even in industry.

It is an incredible mathematical ratio that in some mysterious way seems to harmonize with the human psyche. The Golden Rectangle is built on this ratio.[7] In fact, this shape is so aesthetically charged that architects and other artisans have depended upon it to design their constructions and painters have relied upon it for their image placement ever since it was discovered. It was employed by Leonardo da Vinci when composing *The Last Supper* , by Michelangelo Buonarroti while painting his frescos on the ceiling of the Sistine Chapel and by multitudes of others in famous historical and artistic works. And some analyses of Mozart's sonatas show that used the Golden Ratio in sectional divisions.

Volumes have been written about the Golden Ratio. But what is important for us to understand is how we can use it in placing our images. The two methods we will use are done by approximation, but the reason these work can be found in the writings of Fibonacci.

Leonardo Fibonacci's *Liber Abaci* [The Book of Calculations], which appeared in the 1200s, features a number sequence that parallels the logic of the Golden Ratio. The sequence begins with 0 followed by 1, then added together (0 + 1=1). That 1 is added to the first 1 to get 2 (1+1=2), then the 2 is added to this 1 to get the next number 3. The 3 is added back to the previous number (2) to equal 5, then 5+3=8, 8+3=11 and so forth in a

[6] Also called Golden Section, Golden Mean, Divine Proportion and Phi
[7] A number of extensive discussions with illustrations are available online. A good beginning is www.livescience.com.

sequence looks like this: 0, 1, 1, 2, 3, 5, 8, 13, 21, 34, 55, 89, 144, 233, 377, 610, 987, 1597, 2584…: there is no end.

What's fun about the Fibonacci sequence is how closely any adjacent pair of the numbers is to the golden ratio proportion. Notice within the sequence above two sets familiar to us, the ratios of 2 x 3 and 3 x 5.

As the sequence progresses, the ratio (larger number divided by the smaller number) between each new number and its precursor remains relatively constant, each instance closely approximating 1.618, our Golden Ratio (the decimal places approach infinity). At the same time, by subdividing any rectangle along opposing diagonals, there is within those subdivisions smaller rectangles whose proportions likewise closely approximate the Golden Ratio.

Artists refer to these areas as eyes of the rectangle or divisions of thirds. Either way, if one wants to explore the mathematics of the divisions to compare them with Fibonacci's numbers, there are many published resources for doing so. But for those of us who prefer visual approximations, there are two methods that work.

The Eyes of the Rectangle and Division of Thirds

These methods of placement can be used with rectangles regardless of the ratio of their sides. When the painting surface is a rectangle,[8] rather than placing our key images randomly, we can give them *emphasis*, *movement*, and *order* if we locate them within the rectangle's "eyes."

There are four eyes. Each is a "sweet spot" located halfway between the center and each corner of the rectangle. Another method for locating these sweet spots is to section the rectangle into a grid of thirds horizontally and vertically. The eyes will be located where the horizontal and vertical lines intersect. It's the same principle, just a different way of going about it

[8] As opposed to an oval or circle.

How Composing Works

Eyes of the Rectangle

Division of Thirds

If we place our key images within the vicinity of any one of the eyes, it creates a relationship with the rectangle's edges that approximate the Golden Ratio. We don't need to do any mathematical calculations to place these "eyes." We need only to eyeball that area halfway between a corner and the center of the canvas.

Rabatment

A more nuanced way to strategically place images in a rectangle is called rabatment. On each long side of a rectangle there is an implied square, the height of the rectangle and extending that same measure along the longer side of the rectangle. The imagined line going through the rectangle to form that square is the rabatment. Naturally, every rectangle has two rabatments.

Rabatment

Dianne Mize, *Committee Meeting*, 2007, Watercolor on Paper

Finding Freedom to Create

A painter can make dynamic use of the space on either side of the rabatment when positioning two images relating mysteriously to each other, or when wanting to convey a sense of action/reaction.

Examples are found in Andrew Wyeth's *Christina's World*, where Christina is placed within the square of the rabatment and the old house on the hill is located within the rectangle. Even more evocative, in Wyeth's *The Kuerners*, Carl and his gun are within the square and Anna within the rectangle.[9]

| Square | Rectangle | Square | Rectangle |
| Rabatment | | Rabatment | |

Format and Placement

Once a subject *selection* is made for a painting, the shape and orientation of the physical format upon which the overall image is *placed* will play a large role in the painting's impact.

We design of our paintings and drawings in concert with the support (canvas, board, paper) on which we create them. The edges of the support, its shape, are where the art work begins. In fact, if we are working with a square or rectangle, the first mark we make is actually the fifth: the edges themselves give us the first four marks before we even pick up a pencil or a brush.

A square is noncommittal, because all its edges are equal; therefore they create no tension. A rectangle, however, having

[9] Diagrams of Wyeth's work are produced here with permission of the Office of Andrew Wyeth

two longer sides, conveys a tension through contrast of size—the longer the rectangle, the stronger the contrast with the shorter sides. And, unlike the square, a rectangle can be oriented vertically or horizontally. These choices determine how the subject is composed and how the content is communicated.

Round or oval supports are the least committal of all, because each has only one edge, one continuous line. The first mark we make with the brush will be the new painting's second line.

In many ways, round and square support shapes are the easiest to compose within, because they begin with no commitment. By commitment, I mean that there is no statement of intention within the support's shape, no directional forces built within it.

I compare the painting's support to musical and poetic form: a very small square painting to me is like a lyrical tune, but a large, horizontal rectangular painting reminds me of a sonata. Or perhaps the small square is like a haiku, whereas a large vertical rectangle is like an epic.

Open and Closed Views as Placement

Composing is not just about how the painting is designed, nor is it just about the subject. Rather it is about choices: it is about how the artist selects the subject, how much of it is selected, then how that choice is expressed on the two-dimensional space that also has been chosen.

Sometimes a painter chooses to engage the viewer by giving a limited number of clues about the content of a work, giving the piece a sense of mystery. One classic method for doing this is called *open composition*.

In a *closed composition* the entire subject appears within the edges of a painting. *Open composition* shows only part of the subject. In photographers' language, the image is "cropped." In the first of the photographic examples shown here, we can see that this is a person, but where is she? Outdoors or looking out an open window? What is she doing? Is she

gazing out over a landscape? Is the wind blowing her hair? An *open composition* might crop out information allowing us, the viewers, to complete the story or even to ask questions about the background.

Still an *open composition*, the second photo shows selection and placement that give us more clues. Here we learn that the person is on a bicycle, but is she riding, or resting? Is she wearing shorts, or slacks, or a skirt? Is she making a turn, or about to crash into a fence?

In the third photo image we have a little more information—we know she's wearing shorts, but we still don't see all of the image. We still cannot tell whether she is riding, or resting, or about to crash. Her hair tells us motion is coming from somewhere, but is it from how she's moving, or is it wind? The composition is still *open*.

In the final photo example, the story is more complete. It is a *closed composition,* where the entire image is shown. The girl is riding her bike and about to make a turn from one trail onto another alongside a fence. The only questions left are whether the wind is blowing or whether she's making a speedy turn, where she is going, and from whence she came. This is where we begin to create our own story about her.

One thing to note is that the *closed composition* does not engage us so much as the *open compositions* did. Nonetheless, each of these photo examples of selection and placement has enough information to create a stimulating painting.

Visual language speaks to our senses, our intellects, our intuitions, and our emotions. The use of open composition stands a good chance of strongly tapping into all four.

Contrasting and Emphasizing

Any time a set of opposites are placed together, we have contrast. Wherever we have *contrast*, we have *emphasis*.

Contrasting is among the most helpful of the *worker generators*, because we use it to give clarity to an area or image or to bring the viewer's attention to a particular spot of interest.

A strong light juxtaposed with a strong dark, a highly textured area within a smooth surface, a square within or next to a circle, a vertical direction opposing a horizontal, a strong color next to a more neutral one—all these are potential ways to restore order to a muddled section, to give balance to a wavering or instable area, or to create visual movement in a space that needs to be pulled into the whole work.

Emphasizing is using a contrast of some sort to call attention to something. We can also emphasize by isolating an image, by creating a path that moves toward an image, or by putting the image in an environment that is different from its usual context. By doing this, focal areas are created. Also called focal points, these are images or elements that draw immediate attention. Some artists create these points of interest so that they are the focus of what the painting is all about, but focal points can also be used to pull the viewer's attention into the painting.

Transitions: Gradating and Modulating

A painting with too many contrasting elements can assault our senses much like being suddenly awakened out of a sound sleep. Yet a painting can translate vibrant life, intense emotion, and conflicting action without visually harassing the viewer. Two methods for achieving this are *gradating* and *modulating*.

Arguably the most familiar of all the *worker generators*, *gradation* is a gradual transition between opposites. Light changes slowly to dark, repeated images continuously become larger or smaller, one color gently unfolds into another. Any visual element—whether size, shape, direction, line, value, hue, intensity, temperature, or texture—can be gradated, just as it can be contrasted.

Most of us probably learned early on that we can use value *gradation* to make an image appear three-dimensional, but when this worker is used for unifying a painting, we call it *modulation*. Many refer to both as *blending*. Distinction between the words is mostly semantic.

Modulating does the same thing as gradating, but there is a slight difference. *Gradation* is more self-contained, as within an individual shape, whereas *modulation* is used to describe transitioning over a larger area, even the entire painting.

An example of *gradation* is how light gradually changes to dark over a rounded image such as an egg. An example of *modulation* is found in landscapes where our eyes perceive things moving into the distance as becoming progressively lighter, more neutral, and smaller.

Two other transitioning methods function more like a visual bridge: *lost edges* and *sfumato*. These will lead us to further discussion of edges and their treatment.

Lost Edges

Lost edges happen when a shape is not totally delineated and, instead, a portion of an edge disappears, merging with surroundings of the same value or fusing with other edges rather than separating distinct shapes. Because our perception creates visual closure, allowing us to recognize a shape that has some of its parts missing, when an edge is lost the shape still feels complete.

Lost edges work to make a painting more alluring, because visual closure engages the viewer's involvement by completing the image, making the painting more interesting to look at.

Look for lost edges in the areas circled, then find others within each painting.

Looking Back Oil on Canvas 2011

Double Dare Watercolor on Paper 2013

The Role of Edges

An edge in a painting is like a pause between two musical phrases: it marks the ending of one shape and the beginning of another. The two sides of any edge can be isolated from each other or transitioned into each other, depending upon how the artist has handled the painting of the edge itself.

Whereas hard edges bring shapes to an abrupt halt, calling our attention to them, soft and lost edges enable shapes and images to flow from one area of the painting to another. A soft edge, *sfumato*, makes a gentle transition, but with a lost edge we sense a merging of one shape into another.

Our eyes want to participate, to become involved in paintings we view. We want to be challenged, not spoon-fed. When an artist uses just enough hard edges to bring us into a painting, then strategically employs soft and lost edges, our eyes become curious. We feel invited to become a part of what the painting is all about.

Repeating and Varying

Repeating size, shape, direction, line, value, hue, intensity, temperature, or texture is a reliable way to create in a painting four of the *Results generators*: *unity, order, harmony,* and *rhythm*. But too much repetition of the same kind can become boring. That's why artists pair *repeating* with *varying*.

We all know how unnerving it is to hear the same old tune over and over again. But when a musician adds *variations* to that tune, something that was irritating can be transformed into something delightful. And the more clever the *variations*, the more likely we are to want to hear the tune again. However—and here's a thing to watch out for—*varying* taken to extreme is as disconcerting as too much *repetition*. In creating, everything is a balancing act.

There are abundant *repetitions* in nature, but nature's repeated elements contain *variations* that keep them charged with energy. We can see this in the different petal sizes in a flower or in the diversity of limb angles on a single tree, for example. The artist's ability to capture, even exploit, those *variations* is one way to hold a viewer's attention and to give finesse to your expression.

For *unity, harmony,* and *rhythm,* artists can *repeat* the same color family throughout a painting, but within that color, charge the work with more energy by *varying* the color's hue, intensity, and value. For example, when painting both sky and water, repetition of the same blue translates into a ho-hum interpretation, but varying the intensity and hue of the blues you see will make these areas more compelling.

One Idea, Many Variations

Mozart, being both playful and naughty, took "Twinkle, Twinkle Little Star" and put twelve variations to it, creating an entirely new composition. Just as composers like Mozart often diverge and develop a simple tune, it's not unusual for a visual artist to explore a single idea in an array of works, each

complete within itself, yet having its own unique take on the chosen theme.

Impressionist painter Claude Monet did this often, experimenting with the same subject seen in different kinds of light and from different points of view in his famous paintings of haystacks, as well as in his series on poplars, on Rouen Cathedral, and on the Parliament buildings along the Thames in London. Vincent Van Gogh experimented with self-portraits, as did Rembrandt van Rijn. So repeating and varying can be used among a series of works as well as within individual pieces.

Elaborating and Economizing

Elaborating is adding details. In today's idiom we say "flesh it out" or "unpack it." It all means that we're adding information.

There is a myth in our culture that judges a painting's success according to how detailed it is, but that's a false assumption. The amount of detail or its realistic design has nothing to do with the quality of painting. It is true that in Baroque painting, a European trend developed during the seventeenth and eighteenth centuries, the style itself is characterized by ornate detail, but when excessive information becomes mere decoration rather than necessary to what the artist is saying, the results can be confusing and tiresome.

To avoid this, we reserve *elaborating* for enhancing areas of importance while holding back in other areas. Think of elaborating as orchestrating where we describe the most important areas while subordinating everything else. We want the viewer to comprehend rather than to be assaulted.

When we *economize*, we use only what is necessary, we avoid overloading our work with superfluous decoration or details. *Economizing* curbs *elaborating*. When we reduce the number of details or the degree to which we describe an image, making it more mysterious rather than giving out all the clues, we can inspire curiosity, thus holding viewers' attention.

Edward Hopper and Winslow Homer were especially good at economizing, despite their very different painting styles.

But just as elaborating can be taken to the extreme, so can economizing: too much holding back can leave a painting empty. So these two workers ask for a lot of give and take.

Isolating

To isolate is to set a thing apart, detach it, and give it solitude. In painting, we isolate by closing a shape off with hard edges, placing a light or bright shape among dark surroundings or a dark shape among bright surroundings, by locating a small shape in a large area of a different nature, surrounding a shape with vast space, or by planting a shape among shapes different from itself. Any of these maneuvers creates s a sense of solitude.

We do these things to call attention to an area or to give an image emphasis. Something that is different from everything around it will stand out.

Overlapping

Overlapping is the opposite of *isolating*. Whereas isolating visually separates, overlapping unites. In painting, we overlap when we place one shape or image in front of another. This achieves two things: it creates a sense of depth in space by evoking the perception that something is placed behind or in front of something else, and it ties groups of objects together to prevent their being isolated from one another.

Overlapping is especially useful for avoiding tangents,[10] where edges' touching creates a sense of ambiguity. Painter Helen Van Wyk called these "shapes kissing."

The idea to remember is that when we want to call attention to a specific image, we can contrast it or isolate it; otherwise, overlapping or modulating unites it with other images.

[10] See Chapter 7, section entitled *Composing Trip-ups*

Converging

Each composing generator is derived from patterns in nature, from laws of physics or from how our eyes function.

Historically, a few artists have made scientific discoveries about how these work, formed them into a meaningful system and passed that down for future use. This happened with the physics of how our eyes see receding parallel lines. For this discussion, we'll look at horizontal parallel lines because if we understand how they work, it makes verticals easier to see and render.

To begin, pretend you are looking down the middle of a railroad track. If the track is straight, the cross ties appear horizontal, but the two rails moving into distance appear to be coming progressively closer together. Even though in the three-dimensional world, the rails continue to be parallel, in our two-dimensional perception, they converge the farther the move into distance.

Italian Renaissance architect Filippo Brunelleschi found a scheme for rendering this phenomenon, demonstrating two-dimensionally what happens when we're looking at parallel lines moving away from our eyes. Where those railroad tracks eventually converge is called the *vanishing point*. The horizontal line on which they converge is called the *horizon line*. It exists in the distance on the same plane as our *eye level*. The eye level is the position at which your eyes are located in relation to the observed subject. So the viewer's location determines where the parallel lines converge.

It is important to notice that, like the ties of a railroad track, lines parallel to our eye level do not converge. Those that converge are the ones perpendicular to our eye level whether above, below or on either side of our location.

Imagine standing in the middle of a hallway with a wall at the end. Windows are in both side walls, the ceiling is of rectangular panels and the floor is square tiles. First, label the parallel lines: those on the ceiling, floor and rear wall lines crossing in front of us and parallel to our eyes are called *transversals*. They do not converge, so we need not be concerned

about them. Those lines perpendicular to our eye level and moving away from us are called *orthogonals*. They are the ones that converge.

Whether on the ceiling, floor or side walls, the *orthogonal* lines will all converge at a single point. That point will be on the *horizon line*, usually invisible, but always parallel to our *eye level*.

In this hallway, all the horizontal lines parallel or perpendicular to our *eye level* are straight. On the walls, orthogonals above our eye level angle downward toward the vanishing point and those below eye level tilt upward toward it. On the ceiling and floors, all orthogonals to our right move bend left toward the vanishing point and those on our left tilt right toward it.

Those directly aligned with the eye level do not bend, but move straight to the vanish point. On the ceiling and floor, they appear vertical. On all the walls whether on either side or at the end, they are horizontal. Standing in this hallway, all the *orthogonals* converge to a single point, the vanishing point

See how it works in this example:

What the linear perspective system does is to illustrate for us a system for how our eyes see linear depth in three dimensional space. But we can see it for ourselves without having to know the formula.

How Composing Works

Try this. Hold a yardstick level and parallel to your eyes, and look over the edge of the yardstick across the room where you can see a corner. Without moving the yardstick but letting your eyes roam, notice how the walls' *orthogonal* lines above the yardstick tilt downward as they recede and all those below it turn upward, all converging on the same point.

Turn the yardstick vertical, holding it still and aligned with the vanishing point, then let your eyes survey any lines on the floor. Notice how those to your right, turn left, those on your left veer right, all turning upward toward the vanishing point. Now, do the same for any lines in the ceiling, noticing that they behave the same except that they turn downward.

The number of vanishing points you find in any scene will depend upon the corners in view, such as those inside the walls of your house versus those on the outside. If you are facing the inside bend of a corner, there will be one vanishing point to which every *orthogonal* line is moving. But if you are on the outside of a corner, lines will diverge away from both sides of the corner so that there will be a vanishing point on either side of it, the same as in this photo of a loaf of bread.

Thus linear perspective (or *converging*) is not about the world we see, but *how we see* the world. The miracle of the mechanics of our eyes is how they send messages to the brain,

plus how we interpret those messages to find our way around without tripping all over the place. This is what Brunelleschi was made aware of when he created the system for converging lines that enables us to put onto a two-dimensional surface a three-dimensional perception.

In art as in life, we choose whether we interpret what we see in the moment according to past associations or in relation to what is in the moment itself, or as we would like to see it in the future, whether that future is in an art work we are making or in the life we are making. It's a beautiful thought that we can always choose.

What fascinates me about linear perspective à la Brunelleschi is the horizon line and the vanishing point. We see the horizon line as always horizontal to our eyes, and we see all the other lines in our purview either aligned with it, perpendicular to it, leaning (converging) toward a vanishing point—or just floating around unrelated to it. And the vanishing point always converges on the horizon line, that is, at our eye level.

It also is interesting to me that the point at which lines converge is called the *vanishing* point, when it is actually the place at which all lines come together. What is it that vanishes when lines come together? Where do they go after that? And why is it that when standing in the middle of a room, even the lines on either side of us are aligned horizontally at the level of our eyes? All these are questions that can keep one either giggling with glee or pulling out one's hair. I choose to giggle.

Brunelleschi called his system *linear perspective*. He gave the label *one-point perspective* to space where only one vanishing point exists, and *two-point perspective* to an area where two points exist. There are many others, too, but you can delve into that on your own if it interests you.

Artists use converging lines to lead the viewer's eye to a point of emphasis or to give proportion to structures. Probably one of the most ingenious uses ever of one-point perspective was created more than six hundred years ago by Leonardo da Vinci in *The Last Supper*. Take a look at this:

How Composing Works

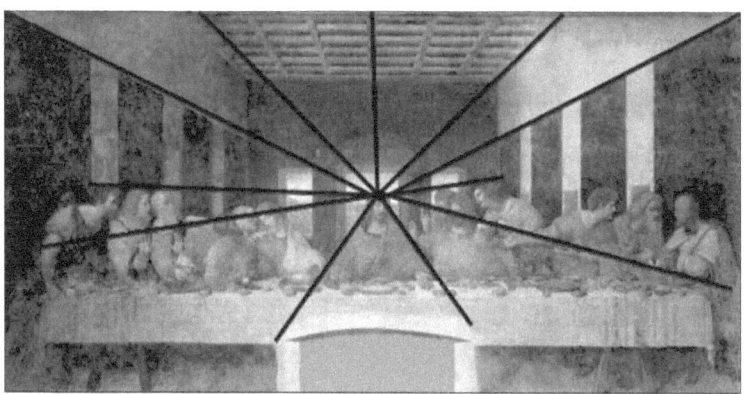

Leonardo da Vinci, The *Last Supper,* fresco, circa *1498*

Assigning Dominance

We could call *dominance* the alpha generator. In life we understand being dominant to mean being the leader or asserting power, or being more influential or prevalent. In music, each key has a dominant chord that is the chord all others lead back to for resolution. In painting, a dominant color is the most prevalent, the one to which all others refer, meaning that they either harmonize with it or contrast with it. Painting also requires a dominant value, meaning that there needs to be more dark than light or more light than dark or more mid-tone than light or dark, depending on the artist's overall intention.

Dominance in any art prevents ambiguity, one of the most uncomfortable and unresolved feelings living beings experience. When something is ambiguous or vague, it creates uncertainty, doubt, and unease. To use the old phrase, the viewer is left sitting on a fence, not knowing on which side to fall.

We can avoid this ambivalence by controlling the proportions of the elements—color, value, texture, shape type, direction, line, and/or size—by making one more evident or active than the others in the work.

Summing It Up

Now you know what I mean when I say that there is a difference between the *worker generators* and those that arise from work being done, the *result generators.* But the workers need stuff to work with, and that is what we look at next.

CHAPTER 6

The Vocabulary of Composing

A poet is, before anything else, a person who is passionately in love with language.
—W. H. Auden

When we paint, we communicate through a rich visual language. Images speak, yes, but how they emerge from our hands determines what they say. Seven simple elements make them possible:

Our Visual Vocabulary

Value
Color (hue, intensity, temperature, value)
Shape
Texture
Line
Direction
Size

 These active elements are the ingredients the generators work with. They are the gas that propels the engine, the heat that cooks the brownies, the wind that sails the ship. They are the very stuff that makes composing possible.
 Here's another way to think about it: just as the verbal language functions through parts of speech, the visual language creates images through visual elements. Using the structure of the English language, we can find a rough parallel between the two:

Verbs act : Values structure
Adjectives and adverbs modify : Colors describe
Nouns name : Shapes define
Interjections accent : Textures intrigue
Prepositions link : Lines lead
Conjunctions connect : Direction controls
Pronouns stand in : Size relates

We do not need to know what a noun is to ask for a refund, nor do we need to know what a verb is to spend the refund once we get it. English-speaking people can communicate very well without knowing a thing about the structure of the English language. But once we *do* know how these parts of speech work, we can use them to express ourselves more abundantly.

It's called communication. As artists we are involved in a two-sided activity: we express ourselves, and we communicate what we're expressing. What we convey can be received with clarity or with confusion among our viewers, depending upon how we use the visual language.

We do not have to risk uncertainty. We can wrap our awareness around how the vocabulary works and make communicating accessible to others while being as flexible as we want to be. The more we know about how to use a language, the freer we are to be creative with it.

Our Seeing Awareness

Understanding visual language is already available to us. It's in our eyes. We use it all the time even if we are not registering that we are using it.

If we are not aware of its power, most likely that is because of chatter in our brains that wants to label and place a value judgment on everything we see. But it is when we can look at a sunset without calling it a sunset or without thinking it beautiful that we really see it.

Try this experiment: Get paper and pen, look out a window and jot down a list of everything you see. In the classroom I

would call for a pause here, while lists were prepared. For now, let's assume you have taken a few moments to do the same.

Back so soon?

Look at what you wrote and put a check mark beside every adjective or adverb you used. If you have none, you saw labels (nouns): you saw things without seeing their qualities. If you have a few adjectives and adverbs, or even a great many, count your nouns and you will still see that they tend to be equally frequent, or more so.

Now, *don't read any farther.* Put the book down and look again. Write a new list, using only descriptive adjectives such as tall, shaggy or greenand no value-based adjectives like good, ugly or beautiful.

As you did this, you just sharpened your seeing awareness. You allowed your vision to bypass the label and to see characteristics. And by not using subjective adjectives such as beautiful, nasty, or ugly, you eliminated your bias and came closer to an awareness of the subjects' attributes.

Take the experiment one step further. Look again, and this time record your list using only verbs and adverbs. Doing this makes you aware of activity, life, and motion, giving you insight into what things are doing.

When we take away labels and bias, we throw open the veils that hang between us and our perception and activate our seeing awareness.

Visual elements are not merely nouns. They are also adjectives, verbs and adverbs. They describe our world and what it is doing. They neither label it nor judge it.

Let's take at them individually and investigate how they work.

Value: The Supreme Element

The British prefer calling it tone, but Americans use the word *value*. Both refer to degrees of light and dark, from the blackest black extending to the whitest white.

Without values we see nothing. At night, if you lose electric power and there is no moonlight, you can only see black. And in a snowstorm in the Arctic, you can see nothing but white. It is where there is a distinguishable difference between light and dark that we are able to see all that surrounds us. Things of similar value mesh together, but the stronger the value differences, the clearer we see things.

So because everything we do in painting depends upon value, it is the most important element of all those in our visual vocabulary. It is the one upon which all others depend. It structures whatever happens.

Color: The Element of Multiples

Of all the composing elements we work with, color fascinates yet baffles students of art more than any other.

Color is easy to see when thoughts don't get in the way of our seeing. Too often our thoughts are telling us what color we are observing, but when we sharpen our seeing awareness, we are surprised at how different what we actually are seeing is from what we thought we saw.

Toward honing our visual acuity, let's look at color the same way we would disassemble a gear to see how it works. Let's break it down and check out how it behaves.

Dissecting Color

Here's how that breakdown goes: Color incorporates four factors: *hue, intensity, value* and *temperature.*

The Color Wheel

We can gain insight into the behavior of color by referencing a Color Wheel, an instrument that arranges hues in a circle according to their relationships. Several versions are in use today, but the most practical for the artist is the simple 12-hue circle built on the primaries yellow, red and blue.

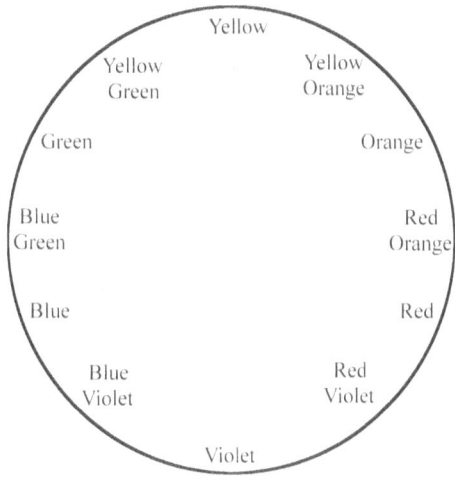

Color and Music

Two thousand seven hundred years ago the Greek philosopher Pythagoras standardized musical tuning into a system he called the Circle of Fifths. It was he who diagrammed the interrelationships of our twelve major keys, an invaluable tool for composers and musicians in Western music. The "Fifth" refers to the interval of a fifth, that is, tones five notes apart (for example, A–E, C–G). The fifth is the most resonant of intervals after the octave. The dramatic opening C–G–C so famous in the overture to the movie *2001: A Space Odyssey* (from Richard Strauss's Thus Spake Zarathustra) is a popular example of this powerful tonal relationship.

Finding Freedom to Create

Within Pythagoras' Circle of Fifths we can locate any major key and find three related chords.[11] On this circle, as shown in the diagram here, every key listed on the outer ring, A through G, has to either side the other two major chords within the same key. For example, for the key of C we see the tonic chord C itself, clockwise its fifth (dominant chord) based on G major, and counterclockwise its fourth (subdominant chord) based on F major The inner circle lists the minor keys related to the major keys, each with its own similarly related chords—to continue our example, tonic A minor, dominant E minor, subdominant D minor. The details of the circle can be further elaborated in various ways.

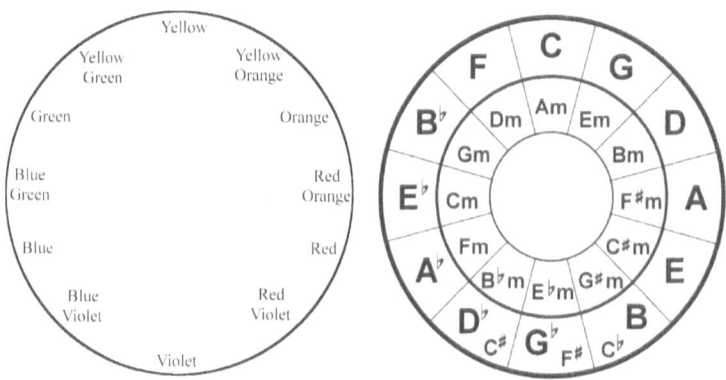

Now here's the fun part: three hundred years later, in the seventeenth century of the present era, the traditional Color Wheel with twelve major colors was diagrammed by English physicist and mathematician Sir Isaac Newton. The relationships of hues found on the color wheel are parallel to the relationship of keys found on Pythagoras' Circle of Fifths.

As the Circle of Fifths is to the musician, the Color Wheel is the workhorse of the visual artist. The more a musician learns about the Circle of Fifths, the richer the music can be, and the

[11] This particular design of Pythagoras' diagram, posted on several internet sites, appears to be in the public domain.

more a visual artist learns about the Color Wheel, the more fertile the possibilities are in painting and design.

And not unlike how a composer sets a musical piece in a key, the artist has the ability to set the *color key* of a painting, giving it the same sort of unity as a chordal key gives a piece of music.

What's so exciting is the similarity between the two diagrams we artists and musicians depend upon and the many parallels in the ways they are used.

The Physical Nature of Color

Hue: The Name Factor

Red, yellow, blue, orange, green, and purple: most folks call these colors, but these are actually a color's *hue*, how we identify their appearance in a rainbow or around a color wheel. The *hue* is the color's name.

The *primary* hues or colors, the ones from which all mixtures derive, are *red, yellow* and *blue*. *Secondary* hues or colors are mixtures of any two primaries: *orange* (red and yellow), *green* (blue and yellow) and *purple* (red and blue). *Tertiary* hues are mixtures of a secondary and a primary: yellow-orange, red-orange, yellow-green, blue-green, blue-purple, red-purple.

Tertiary color is also sometimes defined as a mixture containing all three primary hues. Both definitions are correct in that *tertiary* means third order or third level. But in this book I distinguish tertiary hues, as defined just above, from mixtures of all three primary hues, which I refer to instead as *neutrals*.

It is the set of twelve hues (primary, secondary, and tertiary) that makes up the traditional 12-hue wheel. And it is from combinations among these that we can make any color we see.

Intensity: The Baffling Factor

We use the word *intense* to mean "strong," "energetic," or "heightened." The most intense color contains hue at its most vivid and powerful strength. It is at its highest saturation. The least intense is the hue subdued to nearly neutral gray, a low saturation. Intensity changes when colors of opposite hues are combined. These opposite hues are called *complements*.

For example, on the Color Wheel blue is opposite orange. They have no hue in common, so if a bit of blue is mixed into orange, it will lower orange's intensity. If you continue to add blue to orange, the mixture will eventually turn gray. All complementary colors do that to each other.

In essence, any set of complements contains all hues. Think about it: purple (red + blue) and yellow are complements, and green (yellow + blue) and red are complements, orange (yellow + red) and blue are complements. It's a beautiful thought, toward miraculous, that every color you see is really just a mixture of no more than three hues.

So, if all hues are mixed together in equal strengths, hue becomes neutralized and disappears, just like mixing baking soda into vinegar. It changes from being pure hue to become neutral gray, white, and black. White is a consolidation of all hues in strong light, grays are the same but with less light and black, the same with no light.

The opposite of *intense,* of concentration of hue, is *neutral,* meaning absence of hue. That tells us that neutral gray, white, and black are not hues but *values* without color.

Degrees of intensity, then, are determined by the concentration of hue. Add a little bit of blue to gray and you get bluish-gray—a very low intensity. If you add a bit more blue, the mixture increases in intensity, though still a neutralized form of blue. Keep adding blue, and the mixture becomes more and more vivid. Without any gray, blue is at its height of intensity.

The intensity scale goes from high intensity to middle intensity to low intensity to neutral. To create a scale, you would begin with a high-intensity hue, totally saturated without any

of its complement, and gradually add its complement until the mixture becomes gray.

The names given to the colors of paint we use tell us nothing about their intensity. For example, yellow ochre labels the pigment and hue of that particular yellow, but does not name its intensity, value, or temperature. But if we learn to recognize hues by their intensity, we will know that yellow ochre is a low-intensity yellow.

We are also misled by common names such as brown, rust, olive, or teal. For example, a brown or rust is really a low-intensity red-violet, red, red-orange or orange; Olive green is low-intensity green. Teal blue is middle--low-intensity green-blue.

Temperature: The Harmonizing Factor

The temperature of a color is caused by two things: the hues within the color (its *roots*), and the light under which the color is seen (its *influence*).

On the twelve-hue color wheel, the primary colors, yellow/red/blue, are the *root* colors for setting color temperature. Yellow and red are warm colors and blue is cool, so the blue side of the wheel is the cool side and the red/yellow, the warm side.

Although many argue as to which is warmer, red or yellow, the *temperatures* of a *root* mixture will depend upon how much blue is present. For example, under the same lighting, green (having more blue) is cooler than yellow-green; purple (having more blue) is cooler than red-purple.

Whatever the *root* mixture, how it is *influenced* by the temperature of available light determines how we see it. The yellow of a lemon under a cool, fluorescent light will appear cooler than under a warmer, incandescent light. The grass on a golf course will appear warmer on a sunny day and cooler on an overcast day. It is the temperature of the light, then, that is the harmonizer of everything that it influences.

In a painting, it is the overall *root* temperature that creates its harmony, therefore keeping it in tune. When a painting is finished, we cannot control the *influence* of light under which it will be viewed. But if we harmonize the temperature throughout the painting, it will remain in harmony no matter how it is lit. It will stay in tune with itself.

Color Value

Earlier discussion in this book regarding value has focused on the lights and darks of color, with one exception: when a color's value changes, so do its hue, intensity, and temperature. You can discern this happening if you squint at a solid-colored round object under a direct light source.

For an experiment, place a red tomato under a lamp light, then squint as you stare at it. You'll notice that its redness appears only in a very small area between where the light fiirst strikes it and where the shadow on its surface begins. Hold your eye on this area for a moment, then shift slowly toward the area of the tomato's surface where light is strongest. Notice how the hue changes toward orange, then pinkish or yellowish, to nearly white where the light strikes it directly.

Now, direct your eye back to the red area, then slowly look in the shadowed area. Notice how the red becomes more purplish and less intense than outside the shadow.

A different kind of change happens when we look into the distance of a landscape. As pointed out earlier, in a landscape things to appear lighter the farther into distance they are located.[12] In fact, hues of these colors become more neutral and shift toward the color of the sky.

[12] This is called aerial perspective

Shape: The Element of Limitations

Composers of music work with sound, poets use words, but the visual artist manipulates space. A shape is an area of space enclosed with edges. There are *geometric* shapes—circles, squares, triangles, rectangles, and others with precise edges, and there are *organic* [13] shapes, those with more random or patterned edges and typically found in nature.

Important for artists to know is that every shape has two parts: the area occupied by the shape, and the space surrounding the shape. You cannot have one without the other. It's the yin and yang of shapeness.

> *Thirty spokes are joined in the wheel's hub.*
> *The hole in the middle makes it useful.*
> *Mold clay into a bowl.*
> *The empty space makes it useful.*
> *Cut out doors and windows for the house.*
> *The holes make it useful.*
> *Therefore, the value comes from what is there,*
> *But the use comes from what is not there.*
> —Lao Tse[14]

Since the early twentieth century, space divisions have been called *positive* and *negative,* labels created to distinguish shapes (positive space) from the areas around them (negative space).[15] The label *negative* is misleading, because there is nothing negative about this distinction in the value-laden sense. What is intended is the same sense in which we refer to photographic negatives—an opposite or contrasting effect of some kind. As far as I know, this label surfaced during the

[13] Also called *biomorphic* shapes.
[14] Legendary Taoist philosopher and poet of ancient China, born circa 604 B.C. Translation: Stefan Stenudd, www.taoistic.com. Quote used with permission of Stefan Stenudd.
[15] Up until the era of abstraction, these areas were called *figure* (shape) and *ground* (surrounding space).

Abstractionist era, when images vanished and the painting of space became the major concern. As defined at that time, positive space is space occupied by shapes; negative space is the space between and around the shapes.

In music, the spaces between the notes are as important as the notes themselves, and in painting the space around images underpins their strength. In painting, the negative space helps define the character of the image and determines the relationship between images.

Our handicap in seeing an image's shape is that we tend to label what it is. If when we look at a rock and call it a rock, that label interferes with our seeing the unique characteristics of that rock. But if we guide our thoughts to bypass labeling, and look intently at the shape of the space encompassing the rock, we're more likely to see the real character of the shape.

A really good way to experience positive and negative space is through the *Air Glide* exercise we learned in Chapter 3. To take this exercise a step further, try placing two objects side by side, then do the Air Glide of the space *between* the objects rather than the objects themselves.

Texture: The Element of Intrigue

Texture is a sensory element, communicating how a surface might feel to the touch, variations from scratchy to jagged to soggy to silky to furry to bumpy to soft: a moss-covered rock, a wet street, a rugged mountainside, a wrinkled shirt.

In painting, we use the word *texture* in two ways. One describes the surface quality left by brushstrokes and knifestrokes when thick paint or a thick painting medium is used. The other describes the surface appearance of images in the painting.

In painting, texture can refer either to the overall surface sensation created by brush strokes or knives, or to the tactile quality within or on the surface quality of individual images. More than any other element, texture gives intrigue to any artwork, because it communicates to the sensory.

Line: The Leading Element

Traditionally, the word *line* in visual art can denote three things: (1) a mark made by a drawing instrument, (2) an implied direction, circular, vertical, diagonal or horizontal, and (3) a boundary around a shape.

I prefer using *edge* rather than *line* to indicate the boundary of a shape.

Line as a Mark

Line as a mark is obvious, needing no explanation. We use it in drawing to show contour, such as in the *Cruising* exercise (Chapter 3), for capturing gesture,[16] for hatching, cross-hatching, scribble,[17] and straightforward sketching.

Line as an Implied Direction

Line as implied *direction* means that the viewer's eyes are guided from one point to another in an artwork by some means other than a physical line being drawn. For example, the image of a wolf looking toward a rabbit causes an implied line from the wolf to the rabbit.

Another example is three strong areas of contrast, each in a different location in a painting. Our eyes are drawn to anything in contrast. Consequently, each of these will attract our eyes, drawing them from one location to another, creating *movement* caused by an implied rather than drawn *line*.

[16] See "The Power of Gesture," in Chapter 8.
[17] *Hatching* is the use of parallel lines drawn close together, *cross-hatching* is crisscrossing lines, *scribbles* are continuous looping or random marks. All are used to create value in pen and ink drawings. The closer the marks fall together, the darker the value.

Direction: The Guiding Element

Without *direction*, nothing in a painting would work. *Direction* is that force in nature that keeps us aware of where we are, where we came from, and where we are going—and in painting and drawing it works exactly the same. The way we place values, color, shapes, textures, and line all determine how the viewer's eye will move within the artwork.

Every *movement* goes in a direction: vertical, horizontal, diagonal, circular, or a combination of these. So the *movement* within a painting depends upon *direction* to establish visual paths that make a painting accessible, enable us to follow what the artist wants us to see.

Direction also affects our psychology and the physics of our bodies. When we are in a horizontal position we are at rest, in a vertical position we are anchored to the surface on which we are standing, but in a diagonal position without any support, we are most likely falling. One way artists capitalize on this is with the orientation of the painting. A horizontal format can reinforce a restful feeling within a subject as well as provides a soothing environment for a lot of activity. A vertical format reinforces height of upright or tall subjects, accenting stability.

Counterpoint

What do the melodies "Three Blind Mice" and "Row, Row, Row Your Boat" have in common? Answer: each can be sung as a round. Another answer: they also can be sung simultaneously, the two distinct melodies harmonizing without conflicting. The method of juxtaposing two or more voices in music is called *counterpoint*.

We use *counterpoint* in painting, too, but it works differently than in music. Instead of each part moving parallel and independently of the other, in painting elements move in opposing *directions*, each balancing the other. A vertical will counter a horizontal and vice versa; a diagonal will counter another diagonal moving in an opposite *direction*.

The Vocabulary of Composing

Diagonal countering diagonal Horizontal countering vertical Two horizontals countering a vertical

Dianne Mize, *Lady in Waiting, Approaching Sundown, Snacktime,* Oil on Canvas

Counterpoint as an organizing strategy has been used for as long as artists have been composing. Very simply stated, a horizontal calls for a vertical, a vertical calls for a horizontal, and a diagonal calls for another one in the opposite direction. The abstractionists knew this. Many times it was the primary principle holding their pieces together.

Size: The Relational Element

Size in painting is about ratio and proportion.

What a surprise for me, when I finally realized how small most "dailies" are.[18] Looking through blog after blog of these little jewels, I had perceived them as being at least as large as 9 ×12 inches. I could plainly read 6 × 6 or 5 × 7 or even "postcard," in the notes describing them, but these data failed to translate into true perception—until one of the bloggers showed a little daily side by side with a coffee mug.

Light bulbs! Either the mug is huge or the painting is teeny, which brings up the first requirement for size as a visual element: Size requires clues—there must be a comparison, else size doesn't translate.

[18] *Daily paintings* is a term given miniature paintings done on a daily or almost daily basis and published on an artist's blog.

Size and Proportion

Seeing a single photo of a marble or a tennis ball tells us absolutely nothing about the size of either, but a single photo of the two together tells us about the size of both because we can see their relative proportion to each other.

We can draw the human body's proportions accurately by comparing the length of the head to its other parts. Keeping all the parts' sizes relative to the head (or to any other part for that matter) will guarantee that we render individual parts in their right sizes, therefore enabling us to create a human image in proportion to itself.

In fact, just as the proportion of ingredients in cooking determines the flavors in food, proportion of sizes plays an important spatial role for every artwork we make whether drawing, painting, or sculpting. Once we make the first shape, the size of every shape to follow will be affected by the first shape we made.

Size and Proximity

One way size affects shapes is to show their distance from one another. Our vision is such that the farther away a thing is, the smaller we see it compared to anything in front of it. Looking out my window I can see trees. I can hold up one finger and totally block out a tree not thirty feet away from me. The same finger can block out five trees a hundred feet away. My finger is certainly much smaller than any of those tree trunks, yet its proximity to my eyes makes it appear larger by comparison.

That's called *size relationship*.

Size and Foreshortening

Size plays yet another role-- it also enables us to foreshorten. So, what does it mean to foreshorten, and why is it important to know? Let's begin with an illustration. Look at the two photos of the same female cardinal.

The photo on the right is a side view where we can see the bird's full length, head to tail. The other is a frontal view where we can see the profile of her head, her full breast, and her tail, but we see her head and tail as being substantially closer to each other than in the side view. In the frontal view, the space between the cardinal's head and tail is foreshortened.

The space between two ends of an image appears to shortens when one end of it is farther from our eyes than the other. You can see this for yourself with a ruler and a chair. Place the chair so that you can walk around it at a consistent distance. Stand about four feet from the chair, facing its back, and hold your ruler straight out before your eyes, in both hands, so that you can look over it to see how many inches the back of the chair registers on the ruler. Now shift yourself a couple of steps around and look at how much the chair's back shortens. Keep shifting until you're looking from a side view, and you will see a total foreshortening.

Foreshortening is another one of those miracles of our eyesight that enables us to see the world in proportion to itself.

Wrapping Up the Vocabulary

Now you have met them all, those parts of the visual language that make up how we see our world. You know what they do. You can look around from wherever you are at this moment and see every single one of them at work, describing your

world. They are yours to use in whatever way you choose and so are the generators. Together they work for you. They are your tools for composing.

There is No *Correct* Way to Compose

The whole issue of composition is the redheaded stepchild of visual art, especially in the genre of painting. It is danced around, stomped on, lauded, embraced, idealized, scrutinized, ignored, and yes, feared.

The grand conception that there are compositional *rules* that must be followed is nothing short of stifling to our freedom to create. These misguided ideas about painting say nothing about how humans see and perceive and how they use these abilities to compose.

Composing is a fluid activity. It allows us to make choices about the way we put a painting together, choices that make our work uniquely our own without having to memorize anything or follow any standards or try to replicate or imitate or pursue any preconceptions about how it is to be done. We need only to make ourselves aware of how the generators and elements work in nature and use that knowledge in our own creative way.

A reminder: The reason I changed the language from *compositional principles* to *composing generators* is to help define these operators as ways in which we perceive, not as rules we must follow. It is because of how our perception works that we need visual phenomena to be organized so that we can relate to them. The entities that I call *generators* are tools that we learn by observing them, by using them, and by living them. Their magic is that they make our paintings do what we want them to do. And that they are available to us for when we need them.

When baking a cake, we don't use all the ingredients in our pantry or all the tools in our kitchen: we use only those things needed for making the cake. It is no different when composing a painting. We consider how the generators behave, then we choose and use them according to what we want to happen.

The Vocabulary of Composing

So there is no protocol. There is only the experience of how the *composing generators* work in practice. When we know how, we don't have to think about the method we are using. We are free to create.

There's a bonus to all this. Once we know how to do something, we begin to create our own style.[19] We begin to make new discoveries, to find ways to expand and elaborate on the generators and our craft. We discover that we gather into our personal arsenal favorite ways of approaching our work. That is a part of our unique creative process where we find our freedom.

Composing is the crux of freeing individual uniqueness. It is the voice of our vision. It is the conveyor of our message.

[19] See "Style: The Artist's Hand," in Chapter 1.

CHAPTER 7

The Composing Process

I will not accept boundaries; appearances cannot contain me.
—Nikos Kazantzakis

While we are composing, we are translating, transposing, inventing, or using a combination of the three, depending upon where our imaginations take us.

When we're *translating*, we're responding to what we see, making an image of it as closely as we can to how we perceive it. When we're *transposing*, we're shifting what we see to different forms from what we are seeing. When we're *inventing*, we diverge from the visual world to one we imagine, even though our creation might spring from our seeing experience.

Translating

Translating the visual world works very much like translating a poem from one language into another: in our own style, we render what we observe. If you read the same Rumi poem translated by two different people, you'll notice that the translations are similar, but word choices or even word placement differ.[20]

Visual artists translate according to their individual perceptions. A dozen responses to the same scene will vary in as many styles, but the method for getting there might be the same.

[20] Jalalludin Rumi (1207–1273), thirteenth-century Persian poet, theologian, and Sufi mystic, still much admired and read today.

From Strategy to Creation

Over many eons that artists have been observing the natural world and putting their discoveries into practice, they have discovered processes that make a painting do what they want it to do. We call these methods *strategies*.

What is a strategy? It's simply a plan for putting something together. It's a way we choose to organize whatever we're creating. In poetry, for example, among many strategies, we have the haiku and the sonnet. The first is a strategy for writing a tiny poem of seventeen syllables in three lines; the second, a strategy for a two-part, fourteen-line poem. Many poets today choose free verse, itself a strategy.

In music, the hymn is a strategy, as is the waltz or the symphony. Rap, rumba, jazz, improvisation—all are examples of strategies. When we put the concept in terms of poetry or music, we instantly recognize that each of these has built within it a flavor of expression. For example, jazz communicates a recognizable feeling different from rumba.

In composing paintings, we have strategies, too. By beginning with a strategy, we make a plan to give the painting unity and order within which we can build our balance, harmony, rhythm, movement and proportion while maintaining the expression we want the painting to have.

The Notan

One of the soundest translating strategies is built on light patterns.

Light is the essence of life. Not only do we use the word *enlightenment* to describe our deliverance from ignorance, but most religions use the metaphor of light as a sign of spiritual wholeness. In nature, living plants grow toward light, and it is our natural human tendency to follow light. In visual art, we use light as a visual pathway.

We can distill the way we see light with a simple drawing process called *notan*. It is the easiest way to discern how we see,

Finding Freedom to Create

and is virtually foolproof as a composing strategy because it is based on how dark and light work together to define shapes and shadows.

Notan (pronounced "no tan") is a Japanese concept meaning "dark/light." It is related to the better known terms yin/yang, where yin is darkness and yang is light. In fact the yin/yang symbol, black and white embraced in a circle, each showing a dot (eye) of the other, is itself a notan.

In the discussion of value in Chapter 6 we see that our surroundings make sense to us because of how light hits images. We can reduce these lights and their consequent shadows to a black-and-white pattern that makes a visual thought, a diagram laying out how darks connect and how light carries a path through and around the darks. This will give us the notan of whatever we're looking at, an underlying simplified pattern.

The way it works for a painting strategy is that it condenses all the subject matter to just two values, black (yin) and white (yang). This, then, shows a clear pattern to which we can refer for determining how dark or how light we will make the color mixes for their various locations in the painting, thus giving unity to the painting while being certain it will make visual sense.

The mechanics of notan depend upon our synthesizing shadows and lights into a value scale that works very much

like a piano keyboard. Here's how: Locate middle C, the center of the piano keyboard. Keys to the left of middle C are lower in tone (the yin side), those to the right are higher (the yang side). Dark and light tones on your value scale are similar: dark values are low (yin) and light values are high (yang).

If we create a scale of values where 10 is the darkest, lowest dark and 1 is the lightest, highest light, the space between 5 and 6 would be equivalent to middle C on a piano.

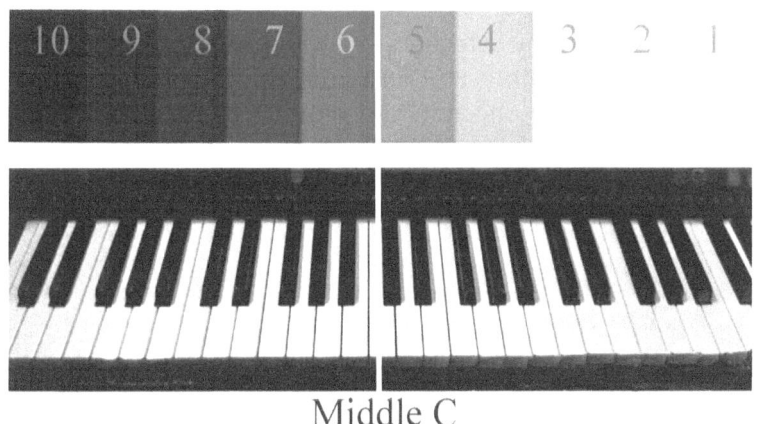

Middle C

Before going further, let's do an experiment:

Look at your surroundings. Make a window with your hand by touching your index finger to your thumb, making the "OK" sign. We will call this window a viewer or viewfinder. Hold your hand up and look through that viewer. You will see that you have isolated or sectioned off a piece of your world.

1. Looking only at what you see through the viewer, close one eye and squint with the other.
2. Hold that squint for a few seconds until all the details fade away and you see only a pattern of dark and light.
3. Now look at just the darks, the parts that are in shadow. Observe how they link together even though some are a bit lighter than others. What you're seeing is a yin pattern of values 10, 9, 8, 7, and 6.

4. Now, shift and hold your attention upon the pattern of lights. Therein is the yang pattern of values 5, 4, 3, 2, and 1.
5. Slowly move your viewer to another spot and then another. Each time pause and register the two patterns.

You can translate these into a notan. This is easily done in a tiny thumbnail drawing using a black felt-tip pen or marker on white paper.

6. We begin by setting up a little format no bigger than 1" × 2". Within that format, using the pen or marker, starting on one side and moving to the other, begin to blacken the pattern of darks we've condensed and allow the white paper to become the pattern of lights. That's all there is to it.

From Thinking to No-thinking

Learning how to do the notan requires thinking at first, but once you do several practice sessions and get the knack of how it works, you will be able to shift into no-thinking. And it's fun to observe how easily you can make this happen.

Try this:

1. With pencil on paper, lay out a dozen or so little blocks, roughly 1" x 2". Keep at least a half inch space between the blocks, more if you like.
2. With your nondominant hand, make a viewer with your thumb and index finger.
3. Looking through your viewer at whatever surrounds you, squint your eyes until all the details become blurred, then shift your attention to just the darks. Notice how they connect to one another.
4. Using your black marker or pen,, record those darks within one of the little blocks. Try to make the darks

fit into the block in the same way they fit within your viewer.
5. Now, move your viewer to another location and do another one. Continue this until all your blocks are filled.
6. Notice that while doing the first block, you had to do some thinking, but by the time you got to the last one, you were either not thinking or doing very little.

Once you are able to do a notan without thinking, you've got it. Keep practicing. It will happen before you know it.

Next comes observing the colors we see and determining how they relate to our notan. To illustrate one way this works, I will give you a glimpse of one of my journaling sessions.

A Brief Journal of Observing and Translating

I'm looking out my kitchen window on a mid- October morning. Living in the woods, I see mostly tree trunks and leaves. I don't see any sky because the woods rise up a hill in my back yard.

Even though a few of the leaves are changing color, most of them are still green. At 9:47 A.M., the sun is shining from the upper left, causing a diagonal pattern of light, creating a triangular path[21] through the woods from the top left to the bottom right and up toward the top right. I squint my eyes to see the pattern clearly and make a notan drawing of what I am seeing.

Where the sunlight is striking the leaves, I see mid-intensity, light yellow-green, gradating to almost low-intensity, light yellow-orange toward the top.[22] Where the light is hitting the tree trunks I see almost neutral light yellow-green in some areas and almost neutral light purple in others. I go outside and pluck one of the leaves to look at it

[21] See Visual Paths as Strategies, *The Triangle Path,* later in this chapter.
[22] See "Dissecting Color, Intensity: The Baffling Element," in Chapter 6.

closely, but its color does not resemble the ensemble of leaves I'm seeing out my window. Those in the shadow areas are in masses of mid-intensity dark warm green and range to a more neutral and cooler dark green. I see only tiny bits of the actual leaf green color in the ambient light toward the front of the woods.

A 10:07, the sun has moved higher in the sky, the light changes so that more of the leaves are in light than when my observation began. I do another notan. I am now seeing more light colors, but they are not leaf green, rather variations of low-intensity, light yellow-green and yellow-orange. In this light, I'm seeing more of the fall colors than were visible earlier. Coming from the top are the brightest lights, varying from light, mid-intensity yellow-green to mid-intensity, light yellow-orange. The distribution of light and dark is more even now, though darks still dominate and form a backwards L shape from the left side into the bottom.[23] I do a notan.

The light continues to change. At 10:30, there is a U shape of dark in front.[24] The colors on the tree trunks are now shifting into orangish-purple. The wind has picked up, so the lights are dappling on the tree trunks, making a dancing motion, sometimes slowly, sometimes more rapidly.

As the light continues to change, my pen dances over the paper as fast as my hand can move to capture another notan of the patterns I am seeing. They are literally changing as I am drawing. The hues are not changing, but the light patterns are. It is now 10:42. If I sit here recording these for the next hour, I will have at least a dozen notans for a dozen paintings, each interpreting the same scene outside my kitchen window, but in different light.

[23] See "Assigning Dominance," in Chapter 5, and "Visual Paths as Strategies, The L Path," later in this chapter..
[24] See "Visual Paths as Strategies, The C Path," later in this chapter.

The Composing Process

The four notans I described above are shown here.. Notice how different each light pattern is. With light shifting so rapidly, there is no way I could capture these changing moments painting *en plein air* and there is no way a camera can capture what my eyes are observing. The best way to capture this is on these little notans and making descriptive notes of how I'm observing the color in terms of its hue, value, intensity and temperature.[25] I can take this further by making quick color studies. But it is important I get the notans first because without the value pattern, the colors would make no sense.

By the way, it is now half an hour since I made the last notan. The greens in the lights are now cooler, more toward light, mid-intensity cool green, and the lights on the tree trunks have become bluer.

There is a way of always finding something new in any subject you choose. Look at it as if you have never seen it before. In fact, no matter how experienced you are or how many times you have been to a place, if you always begin what you are doing as if you have never done it before, you will see and experience surprising things.

[25] See Chapter 6, *Dissecting Color*

Bringing in Color

Spending less than an hour studying the scene outside my kitchen window, I was able to observe far more than I could learn from hours studying color theory. By knowing how to do a notan, by feeling confident in that skill and just allowing it to happen on paper while recording what I was seeing, I was able to capture stories about how light behaves in my woods on an October morning. By understanding how color changes as the light changes and how shadow and light affect color, and knowing about patterns of shadow and light and even about the temperature of light, I was able to make rapidly written notes about what I was observing.

Journaling about what you see while doing notans is especially valuable when working from nature in changing light. But regardless of the subject matter or where it is located, naming colors according to their hue, value, intensity, and temperature can go a long way toward understanding how color works.

Can you imagine these colors as I describe them? I saw mid-intensity light yellow-greens, low-intensity light yellow-orange, almost neutral light yellow-green, mid-intensity dark warm green, a more neutral dark green, low-intensity light yellow-orange, and low-intensity light purple. Even though the hues remained constant, the values and intensities changed dramatically throughout my session.

From Notan to Color

My next step is to use my notan studies as a strategy for painting. That means translating the small notan into color on the painting surface itself, usually much larger. Artists use various methods for this, depending upon the medium they are using. To begin, if I'm using watercolor I do an underpainting of the notan with a light, middle-value ultramarine blue wash on a dampened watercolor paper that I allow to dry before

doing the painting. (I use dampened paper to keep the edges indistinct so that they won't show through subsequent washes.)

If I'm painting with oils, I consult the value scale (shown earlier) and do roughly a value 5 underpainting of the notan in acrylic or tempera. This method of placing the notan on my painting surface as an underpainting makes it it easy to follow without having to think.

Notice that in both mediums, when translating the notan onto the painting surface, I use a middle value. This allows both the dark side and the light side to be set in the lightest value that will appear within their respective areas. It is a safeguard that keeps both value areas consistent, so that when I begin the painting, I will already have set in place the lightest values. This is important because it retains the relationship between those areas in light and those in shadow.

Dianne Mize *10 A.M.*, Oil on Canvas

This method is similar to a poet's decision to write a sonnet or a composer's decision to write a waltz. It sets up the parameters within which the work will be created.

With the notan in place on my painting surface, during the actual process of painting I keep all the colors in the dark roughly between values 10 and 6, and those in the light between 5 and1. Beyond that, I am free to interpret the scene however I choose. Translating my color values within the notan strategy, I can be sure that the lights and shadows will have unity and order, as well as be correctly proportioned within their value areas.

Translating Color

Learning to translate color works the same as learning to translate value, shape, and all the other visual elements: observe and identify. We observe without expectation: rather than telling ourselves what we ought to be seeing, we identify what we are looking at, a color's hue, its value, its intensity, and its temperature.

This is a skill you can build if you are willing to do some color charts such as those Richard Schmid constructs in his book *Alla Prima II*. These exercises will sharpen your ability to read color without having to think about it so that eventually you will know by what you observe what to mix to get the color you are seeing.

While building your color acuity, a good exercise is to journal your observations just as I did alongside my black on white notans, then to recreate those colors with mixtures of paint. Journaling helps clarify your observations.

Whatever you can do to sharpen your sense of observation and your ability to recreate what you observe gives you freedom to create any color you need whenever you need it without having to struggle by trial and error.

Transposing versus Translating

Even though the notan is a direct translation of the dark and light patterns I am seeing, within it I can transpose

the values while retaining the dark/light relationship, giving a new interpretation to the subject.

Before we do that, let's look again at the difference between *translate* and *transpose*. We *translate* the colors and values we observe into the colors and values we make, just as we would translate from one verbal language into another, keeping as close to what we see as we possibly can.

By contrast, in visual art, *transposing* is similar to shifting a piece of music from one key to another. We hear choral groups do this all the time, beginning a song in one key, then transitioning to a different key or shifting to a minor key. We recognize the transposed tune, but it has a slightly different feeling. In visual art, we can transpose in numerous ways. It is a matter of our choice.

One interesting way to transpose within a notan is to change the inner relationship of one or both of the yin and yang areas. For example, within the yin side you can drop values 10 and 9 and most of value 8, and on the yang side, you can drop value 1 and most of value 2. This moves the value relationship closer together. It's very much like shifting a song from a major to a minor key. Most of the painting is done with values 3, 4, 5, 6, and 7. Values 2 and 8 are used for highlights and accents, respectively. Values 1, 9, and 10 are not used.

Another method of transposing value is to drop the middle values, using only those at the extreme ends of the dark and

light sides. One way to do this is to drop values 5, 6, and 7. This gives a more dramatic interpretation of the scene. With only the extreme darks of the scale used to interpret shadow and only the extreme light side used to express the areas in light, the transiting nature of middle values has been removed, causing a stark contrast between shadow and light.

Using notan, the degree to which you can transpose is only limited by what you can imagine. The beauty of the notan is that its structure causes a shadow/light relationship that is readable. That means you could even reverse it (light for dark, dark for light), and it also would still make sense as mirror image.

Color Schemes for Translating and Transposing

A 12-hue color wheel would be a helpful reference at this point. Readily available at art and craft stores, it is one tool that you will use continually throughout your artistic endeavors. It is readily available at art and craft stores.

A color scheme is a selection of colors related to one another by their location on the color wheel or by a characteristic they all have in common. For example, blue, green, and purple are an *analogous* scheme, because these all contain blue and are therefore related closely on the color wheel. They might vary in value, intensity, or temperature, but so long as the scheme does not veer away from the hues blue, green, and purple, it remains analogous.

The Composing Process

Schemes are used in two ways: as a *design*, or as a *limited palette*. In a design, only the colors selected for the color scheme appear in the work. In a limited palette, only the colors selected are used to mix all other colors used in the work.

Decorators, when working with color, use design schemes, but the painter uses either a design scheme or a limited palette, or both together. For example, an interior decorator might choose a complementary scheme of yellow and violet. Within that scheme, various shades or intensities of both yellow and violet will be used in the decoration. In contrast, the painter who chooses a yellow and violet palette might also use mixtures of the two, or even use only mixtures of the two without the actual colors yellow and violet appearing in the painting.

Some schemes can be used to translate the artist's observations, but all of them can be used to transpose. When reviewing the list of traditional schemes below, it is helpful to have a 12-hue color wheel at hand.

Monochromatic: A *single* hue of varying values derived by adding white, gray, or black or a darker or lighter version of the chosen color.

Primary Triad: Red, yellow, and blue. As a *limited palette*, only these three are on the palette. All colors are mixed from them. As a design scheme, only these three colors will appear in the work, though they might vary in value, intensity, and temperature.

Secondary Triad: Purple, Orange, and Green. Just as with the primary limited palette, the palette here is comprised of only these three hues. All colors appearing in the work are mixed from them. As a design scheme, only these three colors will appear, though they might vary in value, intensity, and temperature.

Tertiary Triad : Any *three* from among yellow-green, yellow-orange, red-orange, red-violet, blue-violet, and blue-green, *distributed equidistantly* around the wheel. Just as with the

palettes limited to primary and secondary triads, only the three chosen colors make up the palette. All colors are mixed from them. As a design scheme, only these three colors appear in the work, though they might vary in value, intensity, and temperature.

Analogous Tertiary Set: Any set of *three* tertiary colors having *one primary hue in common,* such as red-orange, yellow-orange, and yellow green, all of which have yellow in common. Just as with the primary, secondary, and tertiary limited palettes, all colors in the work are mixed from the three colors selected. As a design scheme, only these three colors will appear, though they might vary in value, intensity, and temperature.

Analogous Set: Any set of *up to four colors adjacent o*n a color wheel with a primary or secondary chosen as the dominant color, and usually all warm or all cool. Examples would be the set red-orange/orange/yellow-orange/yellow on the warm side, and blue/blue-violet/violet/red-violet on the cool side. The selection chosen as a limited palette will be used to mix all other colors, but as a design scheme, only the selected colors will appear, varying in value, intensity, and temperature.

Complementary: Any *two* colors appearing *opposite* each other on the wheel, such as red/green or blue-green/red-orange. They have no color in common. As a limited palette, only these two make up the palette from which a painting is done. All colors are mixed from them. As a design scheme, only these two colors will appear, though they might vary in value, intensity, and temperature.

Complementary Tertiary Set: Any set of *four* tertiaries where *two* are *complements* of each other and the other two lie between them on the color wheel. As a limited palette, only these four make up the palette. For example, yellow-orange and blue-violet are complements. These two plus either yellow-green/blue-green or red-violet/red orange would form a set. All colors are mixed from them. As a design scheme, only these four

colors will appear, though they might vary in value, intensity and temperature.

Double Complementary: Any *four* colors consisting of *two sets* of *complements*, such as red and its complement, green, with violet and its complement, yellow. Once chosen, these are the only colors used on a limited palette, from which all colors will be mixed. In a design scheme, only these colors appear throughout in variations of value, intensity, and temperature.

Split Complementary: Any *three* colors consisting of a color with its *complement's split set*. Example: yellow with the split set of violet (red-violet and blue-violet). Again, these three colors comprise either the limited palette or the design.

Double Split Complementary: Any *four* colors consisting of *two sets* of complements, where each set has a *color in common* that is a *complement* of the *other set's color in common*. Example: Yellow-green and yellow-orange each have yellow in common. Their complements are red-violet and blue-violet, each having violet in common. Violet and yellow are complements. Both the limited palette and the design scheme work the same as with all the schemes.

Color Schemes as Strategy

When color enters into composition, we can choose whether to translate the colors we see or to transpose them into a different color relationship. A limited palette can provide both options while keeping our work within a harmonious color relationship.

The mechanics of all color schemes work the same, but with different results. Translating with a scheme begins with colors found in the subject matter, whereas in transposing, we begin with the local colors or change them into an entirely new interpretation.

Looking back at my early morning exercise, I translate the colors first. I saw yellow-green, orange-yellow, and cool greens and purples, and I want to begin with what I'm seeing, so yellow-green plays the dominant role and yellow-orange playa a subordinate role, I like the idea of a double-split complementary palette: yellow-orange, with its complement blue-violet; and yellow-green, with its complement red-violet.

How did I know I could do this? I located these two colors on the color wheel, then looked for options among all the eleven schemes.

If you have a color wheel available, look at it while you imagine my descriptions below and you will see why I chose this scheme:

1. **Monochromatic** is out because I'm beginning with more than one hue.
2. **Primary Triad**: I could use red/yellow/blue, but it doesn't feel right to me. How a choice feels is one of the best indicators as to whether it is right.
3. **Secondary Triad**: Mixing from orange, green, and violet would not allow the light yellow oranges and the yellow-greens I see, so this option is out.
4. **Tertiary Triad**: That would be either yellow-orange/blue-green/red-violet, or yellow-green/blue-violet/red-orange. This one would work, but the intensity of either the yellow-green or the yellow-orange would be sacrificed.
5. **Analogous Tertiary Set**: Options here would be red-orange/yellow-orange/yellow-green or yellow-orange/yellow-green/blue-green. With either set I'd have to sacrifice violets. I don't want to do that.
6. **Analogous Set**: My range of options is orange to yellow-green, yellow-orange to green, or yellow-to blue-green. These, too, would sacrifice violets.
7. **Complementary Set**: Likely options could be yellow-orange/blue-violet or yellow/violet or yellow-green/red-violet. Any of these might be fun to transpose to, but I am translating, so I want a range that includes

both yellow-orange and yellow-green, so this option is out.
8. **Complementary Tertiary Set:** Choices from this set are red-violet/yellow-green or red-orange/blue-green or yellow-orange/blue-violet. These, too, would be fun to transpose with, but neither set gives me for both the bright yellow-greens and yellow-oranges I'm aiming for.
9. **Double Complementary Set:** We should note here that all Double Split Complementary Sets are Double Complements as well. There are six sets of complements. Any combination any two of these is a Double Complementary Set. Since my search is for the best colors to mix with yellow-green and yellow-orange for my translation, the choice will be the same as for a Double Split Complementary Set.
10. **Double Split Complementary Set**: Choices here would be yellow-orange/blue-violet with yellow-green/red-violet, a likely candidate containing potential for mixing all the colors I saw, which is why I chose this scheme.
11. **Split Complementary**: Choices here are yellow-orange with violet/blue or yellow-green with red/violet. This combination would yield very much the same color mixes as the Double Split Complementary choice. These two are really a toss up.

If I were to transpose the hue of the scene rather than translate it, I would simply substitute a new set of colors, then decide which scheme would work best to interpret those, using the same process of elimination I used above.

But since it is the color I want to transpose and not the value, I would want to keep the same notan value structure. If the notan has a good balance of dark and light, the painting will make sense no matter what color scheme is used. And no matter how the color is transposed, it is important that all the values remain close to those in the original subject.

Suppose I want to transpose to a monochromatic color scheme. I would chose any single hue to begin the transposition, then use an array of dark and light mixtures of that hue according to how I read the values I am seeing in the scene, placing them where they appear in the notan.

Another way to transpose is to select a color scheme that is totally different from the original colors. For example, the entire painting could be done with mixtures from a limited palette of the complementary colors yellow and violet but retaining the original value.

One interesting way to transpose color is to chose a limited palette based on the original colors, then shift the entire set to the right or left of their location on the color wheel. If I shifted three steps to the right on the color wheel, my original Double Split Complementary Set, yellow-orange/yellow-green with blue-violet/red-violet, would becomea the new set green/blue with red/orange. If I shifted four steps to the left, the new set would be red-violet/red-orange with yellow-green/blue-green.

There is no limit for ways to transpose color. Any scheme can be selected or shifted. The only thing that remains constant is the value.

A fun exercise is to do a notan of some subject, then do a number of little paintings from it, transposing each using a different scheme. That can teach you more about using color than reading dozens of books or even watching that many videos

There is no freedom greater than the freedom of doing.

Regardless of whether we are abstracting or painting realistically, how we use color gives the painting its essence. No other element stimulates sensation, feeling, thought, or intuition to the extent that color does. But it is important to remember that the value of the color is as important to its nature as hue, intensity, and temperature. It is within the color's value that we find its substance.

The Image Solution

Often we painters can trip ourselves up by something I call the "image trap," a block that happens when we become so intent on the images contained in our subject matter that we do not see what they are doing in our painting. This can happen if we become fixated on a single image or if the subject matter includes a lot of content. It happens because our brain switches from "what is it doing?" to "what is it?"

To explain, I like using the term *raw image*, not very elegant, but to me it conveys images, imagined or tangible, before they become a part of an art work. They are the images we select from their environments, even from our imagination. They are why we are doing the painting to begin with. But if these images are interpreted out of the context of how the human brain perceives order and unity, if they are cluttered or fail to relate to each other, the painting feels disjointed, fragmented, and disconnected, conveying confusion rather than expression.

Among the most effective ways to place images in a creative context that visually connects them and at the same time enhances their purpose is to capitalize on visual paths.

Visual Paths as Strategies

Paths give us passage, opening a way for us to move, providing a direction for us to follow. In the arts, we use paths to lead the way through a work and to keep the attention within the work. In music, for example, we use a progression of sounds and rhythms, note by note, chord by chord. In painting, we use movements and rhythms created by how we place images and elements of emphasis on the available surface to create a direction for the eye to follow.

Both nature and our imaginations abound with subjects worth painting, but sometimes abundance comes at a price. If we put too much visual information into a single work of art, our viewers will not know where to look. It's like throwing

them into the wilderness with no way out. But if we select and place those images so that they form a pathway, we create a route enhanced with places to explore and moments to rest.

Paths can be planned, added during completion, or created as the painting evolves. In most cases, their placement will draw the viewer's attention into and through the subject matter. At other times paths might circle outside or inside the main idea, or a path itself could become the subject.

If a strong visual path is *not* present, the viewer's vision may become stalled or trail off without taking in the entire painting. This can happen whether images are placed directly as observed or randomly. But when the artist has created visual paths, the viewer's attention is kept within the painting without awareness that the eye is being guided.

These paths are created when the artist connects certain areas throughout a painting by some manner of visual emphasis. The viewer's gaze will enter a painting at the place *most* emphasized, then move around the painting by way of the paths.

We create these paths with the placement or repetition of images, with the colors we select, and with value contrasts or the directions of strong linear elements. Often these paths are found in the subject matter, ready for us to use or even exploit—and if not, we create them.

Throughout the history of painting, artists have experimented with various methods for creating visual paths. A few of these have become classic, similar to the étude, prelude, or fugue in music or the sonnet, ode, or haiku in poetry.

The paintings shown on the next page exhibit a variety of visual paths and their structures. Notice that within each of the illustrations each path keeps the eye moving in a different way.

The Composing Process

Birds are arranged in a triangular path.

Tree edges and river are arranged in an S path.

Darks along sides and bottom are arranged in a U path.

Darks along top and left in an flipped L path.

Lights of flowers are arranged in an O path.

Tops of trees on both sides and edges of creek converge.

Darks on left gradate towards the distance on the right.

The Triangle Path: A classic path where there are three points of emphasis within the painting, creating a triangular movement.

The S path: A visual movement that forms an S or a Z.

The C path: A pattern of movement seen in a number of positions—as a C or its reverse, curved at the bottom like a U, or curved from the top like an upside-down U or arch..

The L path: Straight-line movements joined such that one forms a right angle from the other, a pattern that can be rotated into any position.

The O or Spiral Path: A circular or spiraling movement either clockwise or counter-clockwise.

The Converging Path: Major lines converge toward a single area in the painting.

The Gradation Path: The eye is guided by an overall light to dark or dark to light gradation, in any direction.

A Single Unifying Device

There are many effective ways to keep a painting unified without losing freshness, excitement, and spontaneity and without retreating to an arid conceptual interpretation or a sensual ploy such as thick random textures or type of construction gimmicks.

One satisfying device is subduing intensity of color throughout. Studying the paintings of Swedish painter Anders Zorn reveals just how effective this method can be. The way it works is that regardless of the intensity of the subject's hue, the artist transposes all the hues toward a degree of neutrality, such as all earth colors. There might be accents of high intensity, but

the dominant intensity is low, giving an overall feeling that everything belongs within the piece.

Another highly effective unifying device to have light of the positive merging into light of the negative, or dark from the positive merging into dark of the negative, a method that American artist and author James Gurney had called *shapewelds*. In his blog *Gurney Journey,* he defines shapewelds as "the linking of light-to-light shapes and dark-to-dark."[26]

American painter Richard Schmid often uses this method. It is achieved by allowing edges to disappear between a light portion of a subject and the light around it or by blending the edge of a shadow side of an image with dark in the area around it. One example *Nancy Painting* on the cover of his book, *Alla Prima II* in which darks of the background merge into the darks of Nancy's clothing. It is the lost edges technique that we discussed in our section about gradating.

Sometimes the subject itself gives us the unifying device we need. The repetition of shapes, colors and sizes such as an orchestra of musicians with their instruments or the people, cars and buildings of a street scene. Even though repeating the same shape and size risks boredom or becoming static, the use of strong value contrast between shapes can keep the piece interesting and exciting.

I would be remiss if I didn't mention using notan as a unifying device. Even though notan is a sound method for a painting with a full range of values, it can be used as a single unifying device by keeping all shadowed areas within a close value range and doing the same within all light areas. Within these areas, incidental accents of contrasting color or value can keep the eye engaged.

Finally, controlling what happens to edges of shapes is one of the most important and too often overlooked unifying devices. No matter the genre, if we make distinct all the edges of buildings, rocks, tree trunks and other outdoor shapes, or

[26] Gurneyjourney.blogspot.com, entry November 11, 2008

objects in a still life or especially the edges within the human figure, we risk making the painting feel jerky, the subjects feel isolated.

On the other hand, if no edges are define or discernible, the painting feels mushy and lacking substance. We leave the eye with no place to go, nothing to latch on to.

Nature is replete with examples of balanced edges, some broken by incidental interruptions, others by light bouncing, some by a change in color or value, some softened by surface coverings. If we study these and use the wisdom we glean from them, we will find far more possibilities than we could have imagined.

Spend some time looking at paintings by realistic painters among the greats and you will find in each some unifying device. Sometimes it's a single device, sometimes a combination, but even when used in combination, one device will most likely be more obvious than the others.

Composing Trip-ups

Even the most accomplished golfer can get distracted and bungle what could have been a perfect swing. Every artist experiences the same kind of disappointment from time to time. That's no reason to get uptight or to live in fear that it will happen again. It's just a reminder to stay present and stay practiced.

Keeping any skill sharp requires practice in order to stay in shape, just as first building the skill requires learning to avoiding moves that can trip us up. Hence it is a good idea to make ourselves conscious of distractions that will spoil our efforts.

One of most frequent of these spoilers is the *tangent*. Being caught off guard by a tangent when painting is like stubbing a toe: it happens when the artist's attention is on other things, as when we fail to notice the chair leg until after we feel the pain. The generic meaning of the word

tangent refers to two things touching, but in painting a tangent is kind of visual touching, bothersome because it creates doubt and ambiguity, or even exudes in the viewer a sense of irritation.

Avoiding tangents is as simple as making ourselves aware of them as bothersome. Once we can do that, we will spot one every time it pops up and swat it as if it were a gnat. The examples on the following page show some classic tangents, with explanations:

Finding Freedom to Create

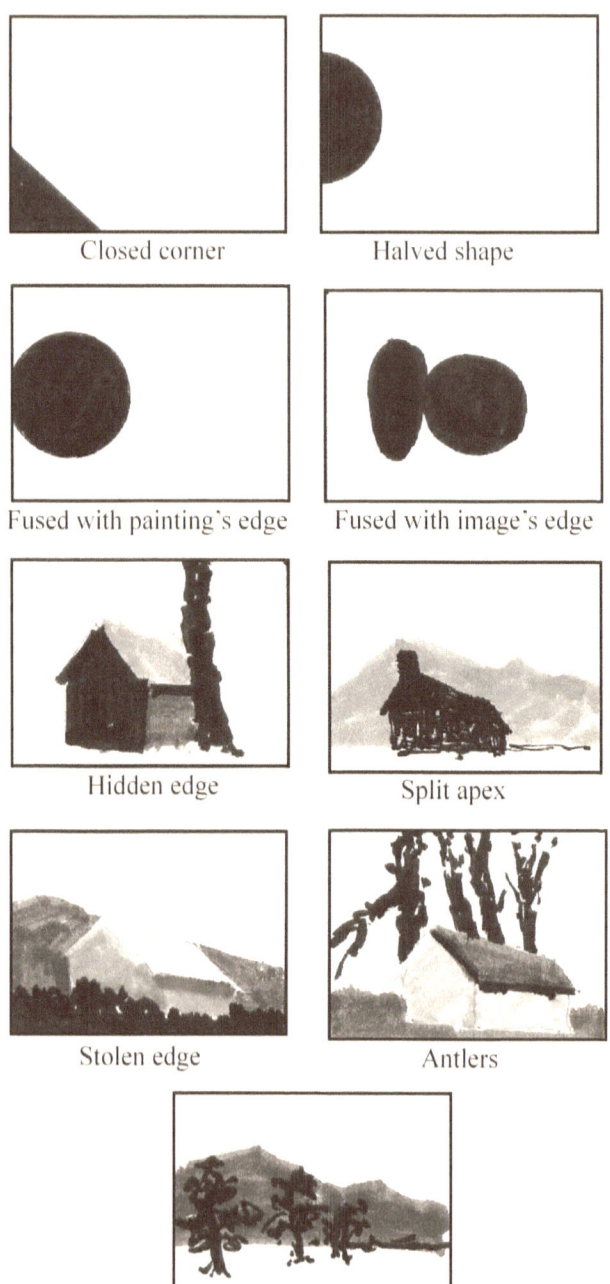

Closed corner: If a shape completely blocks off a corner of the artwork, it can visually isolate that corner from the rest of the painting. However, if a shape is integrated from the corner into the rest of the painting, it can act as a visual lead-in rather than a sore thumb.

Halved shape: A symmetrical shape cut in half at any edge of the painting conveys an uncomfortable, chopped-off feeling. Bringing the entire shape inside the picture plane or cropping the shape somewhere other than the halfway point can instead act as a lead into the painting. One thing to beware of in particular is cropping directly at any joint of an body, (animal or human), the corner or the edge corner of an object or structure.

Fusion with painting's edge: Should the edge of an shape touch the edge of your painting it can create an awkward, crowded, or fused impression. It is best either to extend the shape beyond the painting's edge (though not at the halfway point) or to bring it slightly inside.

This one tricky. It has become an accepted norm these days to have edges of shapes touching the edge of the painting's format. Sometimes it works, but so many times it doesn't. Avoid this unless you feel confident that it enhances rather than weakens the composition.

Fusion with image edge: In realistic painting, when the edges of two shapes touch, they visually fuse together.

Many of today's artists have decided that shapes touching is totally acceptable. I disagree. This practice seems to have begun with artists who were unaware that it poses problems, then was perpetuated by their students and followers.

To prevent the ambiguity of visual fusing, it is best to either overlap shapes or put space between them.

Hidden edge: An edge of one shape that has become hidden behind another, especially when the two are oriented in the

same direction, will cause the two to appear strangely joined together.

This problem is easily avoided either by putting space between the two shapes or by showing a portion of the shape in the rear such that one shape overlaps the other.

Split apex: When a vertical shape intersects or is directly aligned with the apex of another shape, it causes a strange, unwanted symmetry or an arrow sensation.

Avoid this pitfall by shifting the frontal vertical to the right or left or changing your vantage point.

Stolen edge: When the edge of one shape aligns perfectly with the edge of a second shape, it creates an ambiguous edge for both.

Solution? Change your vantage point to allow one shape to overlap the other.

Antlers

When distinct vertical shapes appear directly behind a subject, they often appear like antlers growing out of that image.

This effect can be lessened by reducing the value contrast, losing some edges of the background shapes, or softening their edges

Skimmed edge: When the top a vertical shape ends at the edge of a horizontal one, the two shapes may seem to merge. Most commonly seen are tops of trees seeming to end along the edgeline of mountain tops, but the diagram here shows another not-so-typical example.

Solve this one by raising the vertical object slightly so that it overlaps the horizontal, or lower it so that extra space falls in between.

Awareness means everything. As we hone our sense of seeing, we become more mindful of how images relate and more adroit at communicating those relationships in our paintings.

The Space Between

In music and in visual art, our attention is drawn to the sounds and images, but underneath those is a rhythm created by proximity. The spaces among those sounds and images are where their rhythm lives. We call these spaces intervals.

Generally, an interval is a space between two things. In music it is the time lapse between two notes, in painting it is the space between two edges. Combine several intervals into a pattern and you've got rhythm. The space between is as important to the rhythm as the notes or the edges themselves.

When many intervals are equally spaced, we have a type of staccato response: the viewer feels bored and restive, or the effect seems hypnotic or synchronized. Military parades and marching bands use hypnotic rhythms to keep large numbers of people in marching order by keeping a cadence consistent.

In painting, equal spacing of intervals is functional when staccato is the intended effect. But when equal intervals sneak in unintentionally, they cause a static quality that can interrupt the flow of the painting. In that case, guiding those intervals toward unequal spacing will prevent an unwanted parity.

Three kinds of spacing create a painting's intervals: the space between a shape's edge and an outer edge of the painting, the space between any two shapes within the painting, and the lesser shapes within a single shape itself. When these spaces are too similar in size, the painting's rhythm can suffer; unequally spaced intervals will create a crisper rhythm.

We notice this effect in music when a series of quarter notes without any variation become insistent or monotonous. In painting, equally spaced images or divisions feel abnormal and unresolved, creating a feeling of ambiguity. Our need for variation makes us want more space between some shapes and less in others. We want a rhythm that is almost akin to our heartbeat or our walking pattern or our breathing—recognizable, but flexible and steady though sometimes variable. We want what nature wants and provides all around us: patterns made from unequal intervals. After all, it is within nature that we find our most ingenious principles of composing.

When setting up a painting's composition, there are two kinds of intervals that can become problematic, especially in a landscape. One is how we divide the space between earth and sky; the other, how we space repeated images, especially verticals.

The brain's tendency to space things equally requires that the artist to be especially alert when dealing with repeated verticals such as tree trunks and fence posts.

One other genre requiring special attention to intervals is the portrait. Special awareness to the intervals between all parts of the image and the edge of the painting can be as important to a portrait as the interpretation itself.

It is the variation of the intervals that keeps a composition convincing and entertaining.

When Not to Think

Perhaps the most important thing to learn about composing is when to think and when not to think. Conscious thinking can inhibit and block any act of creating, yet we must use conscious thought to learn and to plan. That means that a big part of finding freedom to create is to develop an awareness of our thinking processes and how we use them.

To illustrate, imagine Mozart's pen moving at breakneck speed, musical sounds registering in his brain with each notation and chord shift that he makes visible on the blank score sheet. Envision how each sheet fills up with notations, looking like tracks from a major bug race to anyone except a musician who can read it.

I don't see what we do as painters as being much different. But here's the sticking point: Mozart was not born knowing how to write music, just as we are not born knowing how to read or write an English sentence. Mozart enhanced his raw talent by studying and understanding the language of music and of how to compose it. And because he had learned so well, he could write music without thinking, in an unconscious

mode of his creative current, putting it within the form he wanted it to take.

American race car driver Danica Patrick was not born with driving skills, much less a knack for high-speed driving. But she was go-karting by the time she was ten years old. She was learning how to race. With conscious attention to the science of her sport, she has perfected the skills of driving so well that on the track, her response is within the creative current, therefore quick and controlled.

Although separated by more than two centuries, these two enormously talented people share a strong connection. Each informed the conscious mind in the mechanics of their crafts, of how to sequence motions and make them work optimally. Within this process, each developed an individual, unique style, – guided by highly intuitive responses to the moment. Without a foundation of conscious learning, their ultimate efforts would have been mediocre at best.

Conscious thinking must precede the creation. It must be a part of the learning process. It all goes back to the right-brain/left-brain duality: the right brain only can function at its maximum when the left brain has functioned at its maximum. The left brain learns a skill, principle, or technique until it becomes a habit, which is filed in the unconscious mind. The right brain can access the skill while engaging in its creative activity. The left brain identifies, the right brain responds and expresses.

It is healthy to make ourselves aware of the composing generators, the analytical activities, freeing ourselves as artists to be more creative as long as conscious thought of those generators does not interfere and stifle the process.

What we want in the long run is holism: we want the muse to guide us as we respond directly, but we also want to know what we are doing, so that we do not have to interrupt the creative process while trying to figure out what to do next.

In response to one of my *Compose* blog posts, Florida painter Linda Blondheim said this: "I like to think of our design tool box as the underpinning or foundation of our possibilities. We know we have the solidity of this knowledge at our disposal but

the more adventurous free spirit lifts us above the foundation to create the top floors."[27] If we know what to do, we can drift into the creative current and allow ourselves to respond freely in the moment.

When Not to Compose

One spring, I visited a sheep farm to watch the annual shearing. I had expected to see the shearing process, but had not anticipated that everywhere I looked there would be subject matter. It was close to overwhelming.

 I saw potential paintings in every direction, hundreds of them. At first I was a bit stunned by the overload of images: a newly sheared sheep on the way back to pasture, freshly sheared sheep grazing, a young girl riding her bike, llamas in the back pasture guarding the sheep, unsheared sheep in the holding areas, sheep being shifted in place for a shearing, and the shearing, itself.

 And it all was in motion. Positioning the camera and taking pictures as fast as I could, I still was missing the in-between shots. There was no time to think. And certainly no time to compose. It was simply a gathering of raw images while trying to stay aware of all the surrounding sensations—the smells, the sounds, the atmosphere.

 This is another side of being a painter. Collecting images is a time *not* to compose, just to tune into whatever gets your adrenaline going and to gather as much as you can. It's the flip side of having your subject in the studio with plenty of time to study it, or of setting up to paint on location where the moving light or the changing weather are the only things that make you hustle.

 What I do with the images may or may not be significant. They could end up filed in the archives of my computer or they could become the subjects of a spate of work. That does not

[27] *Compose*, www.visualcomposing.blogspot.com, *Using Tools: Conscious or Unconscious?*, September 27, 2008

matter. What does matter is that I not miss an opportunity to record something that spoke to me, even if I did not understand at the moment what it was saying.

Convention Breakers

There is a difference between conventional rules of thumb and composing generators. A rule of thumb is an accepted guideline acknowledged informally among artists. A composing generator is a functioning law of physics that gives an artwork form, so that it can be read without confusion.

One of these conventional rules of thumb tells us never to place an area of interest in the center of a painting. But this convention can be successfully nullified by an artist who understands the principle of balance, the law of physics relating to equilibrium: elements visually heavier on one side will overpower lighter-weight elements on the other.

One way to redress the "never center" convention is to use *symmetrical balance,* which makes one side of an art work a mirror image of the other. Painter Georgia O'Keefe employed this principle in her painting *Cow's Skull: Red, White and Blue,* and Leonardo da Vinci used it in the *The Last Supper.* We also see it in Raphael's *School of Athens.* Images do not have to be precisely mirrored, just placed and shaped similarly.

Another method for getting around the convention of "never center" is to use *radial balance,* where elements circle around a central area, or where all elements extend out from the center. Henri Matisse used this principle in his painting *Dance I,* and Albrecht Dürer used it in his etching *The Lamentation*

The convention of avoiding placement in the center of a painting presumes instead an *asymmetric balance,* whereby elements on either side of an artwork's center are of different sizes, colors, textures, shapes, and values. As the notable examples just cited demonstrate, though, an artist who has a working knowledge of the balance principle can find a way to place an area of interest in the center of the work, offsetting it with active elements around it.

Winslow Homer uses this tactic in his painting *The Herring Net*. Even though the event is set right in the middle of the canvas, our eyes are drawn away from the center by the fish in the net on the lower right, the light reflecting on the water on the right side, angles of the oars, and the weight of the fellow hanging onto the front left of the boat. And boats in the distance as well as the floating barrel in front help to distribute the visual weight away from the center of the format.

Rules of thumb usually do work to prevent troublesome confusions from spoiling an otherwise well-done painting. But artists need not be bound by them if n use of a well-chosen alternative principle can override the rule. In fact, the more familiar we artists become with the composing generators, the more options we give ourselves for finding creative ways to make our works more compelling.

The Zen of Composing

Composing is about making decisions, but decision making need not be limited to intellectual choices. In fact, some of the best artistic decisions we make are intuitive. After all, it is within our intuition that we find our inner voice.

As I have repeated again and again, our intellect plays an important role in our learning the mechanics of how composing works, and we need that; otherwise, our work would suffer. In fact, those who would argue that learning composing generators is limiting are both misinformed and naive. But we are not unlike Olympic champions who hone their craft assiduously but perform their best when depend upon their tuitions when actually exercising their craft.

And it is within our intuition that we make discoveries. Our intellectual knowledge enables us to recognize, understand, and communicate what we have discovered. It enables us to grow out of ignorance. But without intuition there would be no such thing as creativity. There would be no scientific discoveries, no new inventions. I would argue that the finest art grows out of knowledge and intuition working together

in balance. We need to acknowledge that too often artists fall into a trap of blocking intuition when needing to make judgments. With our eyes tracking backward while we are working, it is easy to deem what we have done as inadequate. Artist-author Frederick Franck has described what I think is an ideal approach toward breaking through this potential trap.

Franck's *Zen Seeing, Zen Drawing* guides the artist past the self-critical phase into an attitude of being with the subject so that the artist responds to what is being seen without becoming hung up on whether the response is "getting it right." Franck guides the reader through simple exercises that when practiced daily becomes a journey of seeing rather than just looking.

The value of being able to do this, as I see it, is freedom from efforts to make our work acceptable. We then lose that tendency of judging ourselves inadequate and can instead grow in confidence--confidence in our painting skills, confidence in the way we use them in composing, and, most important, confidence in allowing access to our inner voice.

CHAPTER 8

Claiming Creative Freedom

To thine own self be true.
—Polonius (*Hamlet,* Act II)

Deleting Fear

If my teaching could serve nothing more than eradicate fear and self-doubt, I would have accomplished a grand purpose. Fear is the single factor that cripples creative freedom. The majority of the time, it is so deeply rooted of our unconsciousness that we accept is as a part of who we are and avoid those things that activate it.

On the first day of my beginning drawing classes, fear was the most evident of energies entering the classroom. I found myself using whatever means I could invent to sneak in the back way and prove to doubting students that they already knew how to draw, that my role was to prove it to them by showing them some tricks of the trade.

When we avoid something we would like to do but are afraid to try, it's often because we think we don't know *how* to do it. Once we are shown a way to go about it that makes it look achievable, our next reservation is that we won't do it right. These doubts are the fear raising its ugly head, not the reality of what can be accomplished.

Before my nephews were old enough to go to school, I watched as they drew without hesitation, cheerfully and lightheartedly. Children do that. Apprehension does not occur to them. So from where do those fears originate? And when do they set in?

If from the day we were born, others anticipated for us only that we grow into the individuals we were born to be, and if that intention held throughout our developing years, self-doubt would never occur to a single one of us.

As children, a crayon in hand meant watching something magnificent flow from our fingers onto paper. But when it became important for that splendid exercise to meet with approval, apprehension began to set in, the brakes were applied, and self-judgment took hold. It became that little voice in our heads that tells us we are not good enough at what we do or that we might as well not try because we'll just mess up or that we'll be punished if we don't do it right, whatever it is.

There is no reason why any self-mistrust need live another day, most especially for those who really want to be free to create. Any concern that we are lacking ability is brain chatter: it's what clinical psychologist Tara Brach, Ph.D. calls *trance.* In her book *True Refuge,* Brach refers to this state as "our deeply familiar stories of failure or blame . . . that divide us . . . from our inner life. . . . Our identification with a small self." She goes on to explain that these stories get formed in our minds from past experiences when we deemed ourselves unworthy.

As opposed to the positive *creative current*, itself a trancelike state, Tara is speaking of the negative trance that gets reinforced each time we believe the story replaying itself in our heads. But no matter from where the stories came, they are not who we are and they do not define what we can do. They may very well produce a deep feeling of "I can't draw" or "I can't draw well enough," but that feeling is a false message that can be broken if all that chatter can be delegated to the past and replaced by a new experience in the present.

That becomes attainable when we recognize the inadequate feeling as trance rather than reality and make the intention to wake up to a new realization that this moment in time is unique. Now is not the past, but an opportunity to make a move forward into a new reality instead of allowing the old stories continue to limit the possibilities within us.

Wherever the trance lives, whether it is apprehension about drawing, or uncertainty around composing or mixing

colors, or simply pushing a paintbrush, it can be broken open and spilled into oblivion by replacing those old fears with new potential.

I know that real release is realizable. I know that fear is the only thing that stands between a person and their ability to create. And I know fear can be blasted to smithereens by taking one step at a time toward freeing that observer that lives within each of us into action. And I am convinced that the first step toward freeing the inner artist becomes possible by learning to draw without fear. And that can be done by letting go of thoughts and being present in the moment of drawing.

There Is No Correct Way to Draw

Apprehension about drawing often is caused by thinking there is a correct way to draw. No, there is not. No more than there is a correct way to breathe or to go to sleep or to wake up. Drawing is a natural response to what we are seeing.

Drawing for me is like taking a trip. I pick up a drawing tool, place it on a surface, look at a subject, and start scanning it with my eyes, and as I do, the drawing tool follows along, happily leaving a path. The hand is in automatic mode, obeying whatever the eye tells it to do. Thinking is set aside.

Drawing is like being carried away by music. You're humming the tune, not thinking about the notes or chord transitions or rhythm. Drawing is like a canoe ride on a quiet river, thoughtlessly paddling, feeling the air in your face and the sensation of floating on water. Drawing is like eating an apple, smelling a flower, touching the soft fur of a kitten, hearing a cardinal chirp. Drawing is pure responding. It is allowing discovery without expectations or prerequisites or hesitation.

Why, then, if drawing is so simple, do so many people tighten up and avoid it? That is because there are two kinds of drawing: *free drawing* and *filtered drawing*. Free drawing comes from the right side of the brain—that part of us that feels and responds. Filtered drawing comes from the left side, the part of

our brain that collects data and analyzes information. Filtered drawing expects, whereas free drawing reveals.

Filtered drawing, too, is a trip, one with road blocks and detours looped in the space between the eye and the hand. In *free drawing*, the brain provides a clear path through its right side, allowing the hand to respond without hesitation to what the eyes are seeing. But *filtered drawing* streams through the left brain, presupposing all kinds of assumptions that block and change what the eye receives.

Filtered drawing allows little if any right brain participation. Filtering thought patterns are why the person holding the drawing tool contemplates, hesitates, and makes big scary plans before allowing the tool to touch the drawing surface.

My role as teacher is to help my students find ways to counter the left brain's tendency to dominate and to convince it to let go of its precious possessions, allowing the right brain to take command. In Tolkein's *Return of the King*, Frodo did make it to the Cracks of Doom and the ring did get destroyed.[28] Believe me, convincing the left brain to let go won't require your getting your finger bitten off.

The Air Gliding/Phantom Drawing/Cruising exercises recommended in Chapter 3 will work to facilitate free drawing when practiced on a daily basis. This trio of exercises is planned to fool the left brain, to tease it into letting go and allowing the right brain to take charge. Like replacing any old habit with a new one, repeating any new action is what makes it work. And it can and will work, given patience and persistence.

The Power of Gesture

Another freeing skill for transferring ownership of the mind from the left to the right brain is *gesture drawing*. Rather than following edges, our eyes, and thus our hand, follow movement. Gesture drawing is a kind of rhythmic scribbling that records action.

[28] J.R.R. Tolkein, *The Return of the King*, Chapter 3.

Finding Freedom to Create

What happens during the process is that the hand feels the lifts, droops, pushes, pulls, thrusts, swings, glides, swerves, twists, swags, lurches, crawls—whatever action is there, and records it on paper.

As implied in its label, gesture drawing is literally a drawing of gesture rather than description. Seeing a shape's movement allows us to see more than information about it, it allows us to feel what the shape is doing. Drawing movement frees us to experience the energy and life within our subject and helps build our spontaneity. It is not a substitute for the shape, rather a part of its essence. For example, rather than following the contour of drooping shoulders, we are drawing shoulders drooping.

Two of my gesture drawings from a live model illustrate both the speed and the motion captured in the lines on the paper. Long, subtle curves cause our eyes to shift more slowly; short, abrupt curves move the eyes faster. We zip right along straight lines and leap from segment to segment when a line changes direction.

When we allow the pencil to meander with these visual movements in quick, rhythmic marks--as if scribbling--we express the shape's gesture even when the subject is sitting still. A viewer will directly recognize what the subject is doing, rather needing a description.

How To Look at Gesture Drawing

Gesture drawing lines sprawl around. Because they are a response to movement, they are free-flowing and nondescript, but often you can read within them some semblance of the subject. Even so, what the subject is does not matter; what matters is how it is moving. It is the subject's activity that you are responding to.

In our culture, where drawing is generally misconstrued to be about replicating images (rather than about responding to them), most people who look at gesture drawing are blocked by their own expectations from seeing the merit of such drawings. Knowing this, students often hesitate to show their gesture drawings to friends and family for fear of negative reactions. The irony in this is that our museums hold, and treasure, thousands of gesture drawings left to us by great artists like Michelangelo, Leonardo, Raphael, and Titian.

Learning to do gesture drawing adds speed and confidence to the eyes and the hand, so that we are able to respond to a subject without hesitation. Eventually the hand will freely capture both the image and what it is doing, while also recording our own individual perceptions. But for this to happen, we need first to learn to draw just the gesture itself, without regard to what the image looks like.

Your gesture lines will be sweeping, dipping, turning, flowing, rising, falling, or doing whatever is happening with your subject. Seeing any of these motions on paper tells you that you were gesture drawing. These are what you look for within the drawing you have done.

Approaching Gesture Drawing

Folks approaching gesture drawing for the first time might be confused about how to draw movement. I have devised a method for getting the knack of that by connecting it to a dance movement. It's an effective way to transition from drawing description to drawing gesture.

A Word about Movement

A simple movement takes either a straight line or a curve and goes in a vertical, horizontal, diagonal, or circular direction. The movement of falling, for example, is a straight vertical, but the movement of rolling is a curve going in a circular direction.

Learn A Tempo First

Gesture drawing is done with gusto. Going too slow stifles the movement and inhibits spontaneity, but going too fast can skirt the gesture itself. To ease into gesture drawing, it helps to build a tempo—a speed-- that's neither too fast nor too slow. A lively waltz tempo—think *Blue Danube, Sidewalks of New York,* or *Tennessee Waltz*—is a comfortable beginning speed and, being predictable, it's easy to follow.

You will be drawing the movement in a waltz tempo in a variety of directions.

Since gesture drawing is about movement, our first three exercises will be *feeling* movement rather than seeing it.

Waltz Tempo Starter

Begin with an inexpensive medium-sized or large drawing pad, sketchbook, or even a stack of newspaper sheets[29] attached to a board and a couple of well sharpened soft pencils or a mechanical pencil with HB lead. Place the pad on an easel or somehow propped upright, and arrange yourself so that your hands, arms, and body are able to move freely.

The job of the eyes is to stay closed. because this is a feeling exercise, not a seeing one. The job of the mind is to imagine, and that of the hand is to follow what the mind is imagining. Stay aware of your breathing.

Hold your pencil as described for the Cruising Exercise in Chapter 3—your natural writing grip, but with your index finger extended parallel to the pencil's barrel.

Read these instructions, then set down this book and do the exercise:

Movement: Vertical rising and falling to a waltz tempo

The Exercise:

1. Stretch your arms and shoulders. Take a deep breath. Place pencil at the top center of your paper.
2. Close your eyes.
3. Think of a lively waltz tempo, then begin counting 1-2-3, 1-2-3, . . .
4. Within that tempo, imagine the sense of your hand falling-rising-falling, rising-falling-rising, falling-rising-falling.
5. Allow your pencil to do that on the paper: Falling on 1, rising on 2, falling on 3, then rising on 1, falling on 2, rising one 3, and so on. Keep to the waltz tempo.

[29] You can use either blank newsprint or printed newspaper. If you're feeling shy about this, the print of the newspaper will somewhat hide your marks, giving you a bit of an edge on building your courage.

6. Continue for about a dozen rounds. Pay attention to how falling and rising feels.
7. Stop. Open your eyes. Take a deep breath. Stretch your arms and shoulders.

That's gesture drawing.

What gesture drawing does is to allow you to feel what is happening. Building this into your drawing skills will strengthen the right brain's response and make you more relaxed. It is the left brain that causes hesitation and tension. The right brain does not make any judgments. It just responds.

The Triangle Waltz Tempo

The second gesture exercise will be just like the first, except that the movement changes.

Movement: diagonal sweeps in a triangular motion. We are not drawing a triangle, but the motion within a triangle. The first stroke sweeps along the first side of a triangle, the second sweeps along the next side, and the third, the next, all in the waltz rhythm.

The Exercise:

1. Stretch your shoulders, arms, and hands.
2. Place your pencil at the center of the top of your paper.
3. Close your eyes.
4. Take a deep breath.
5. Start counting 1-2-3, 1-2-3, 1-2-3, to the waltz tempo.
6. Imagine the sense of your hand sweeping in a triangular direction, taking the first leg of the triangle on count 1, the second on 2, and the third on 3.
7. Allow your pencil to record that movement on paper, moving around the triangle six times.
8. Stop, open your eyes, and take a deep breath.

Fibfa

What is *fibfa?* It's an acronym for another kind of movement. This gesture repeats a single mark, as we did in the Waltz Tempo Starter. F̲orward, B̲ackward, F̲orward A̲gain: FBFA, pausing each time before changing directions. *Fibfa*: it's a dance movement on paper.

Sometimes when gesture drawing, we draw the movement rapidly in a single forward motion, as we did with the triangular movement, but at other times we explore each movement Forward, Backwards, and Forward Again. This little fibfa maneuver reinforces our awareness that any visual movement goes both ways.

The Fibfa Waltz Triangle

Movement: Fibfa dashing over each leg of a triangular direction, to the waltz tempo. On each of the triangle's sides we dash *forward* on 1, *backward* on 2, then *forward* again on 3, pausing ever so slightly before changing to the direction to the next side.

The Exercise:

1. Stretch your shoulders, arms, and hands.
2. Place your pencil at top center of paper.
3. Close your eyes.
4. Take a deep breath.
5. Think of a lively waltz tempo and begin counting that rhythm—1-2-3, 1-2-3, 1-2-3, keep counting.
6. Within that tempo, imagine the sense of your hand dashing fibfa along the first side of a triangle, pause, then on the second side, pause, then on the third.
7. Take another deep breath.
8. Allow your pencil to draw that movement.
9. Continue for six trips.
10. Open your eyes and take another deep breath.

So far we've explored only movements going in a straight line. To explore the curve, let's do some fibfa waltz movements around an oval.

The Fibfa Oval Waltz

Movement: arching-over/arching-under an horizontal oval.

The Exercise:

1. Stretch your shoulders, arms, and hands.
2. Turn your paper to a horizontal (landscape) orientation.
3. Place your pencil point on one side of the paper, about halfway between top and bottom.
4. Close your eyes.
5. Take a deep breath.
6. Begin counting to set your pace, 1-2-3, 1-2-3, to the waltz tempo.
7. Imagine the rhythmic arching-over of the top side of an oval, forward, backwards, forward again, slight pause, then fibfa again, several times.
8. Allow your pencil to do that on paper.
9. Pause just slightly, because the direction is going to change.
10. Imagine reversing direction, to turn and continue along the bottom side of the oval, doing arching-under fibfa.
11. Allow your pencil to do that on paper.
12. Now that you know how it works, do four complete Fibfa Waltz trips around an oval.
13. Open your eyes.
14. Take a deep breath.
15. Stretch your arms and shoulders.

Combining Directions

Now that you have experienced both the single-direction waltz gesture and the fibfa waltz gesture, try doing both with the shapes of numbers. Notice the gesture in the shapes of numbers: 1, 4 and 7 are always straight made of straight lines, 0, 6 and 8 are always curves, but we vary on how we shape 2, 3, and 9. Play with these variations as you become more acquainted with the gesture waltz method.

Try it with the alphabet or your own scribbles. As you take the trips across the paper, notice what each motion is doing: lifting, drooping, pushing, pulling, thrusting, swinging, gliding, swerving, twisting, swaging, lurching, crawling . . .

Naming Visual Movement

Earlier I mentioned the brain chatter that causes us to hesitate and be apprehensive about drawing. The exercises above are designed to replace that chatter with a job for the mind to do: to imagine a named motion and to count the waltz tempo.

If you have done these exercises, you have had a new experience that has prepared you for the next step: seeing motion and drawing it. While transitioning to this next step, we will feel and name the movements before drawing them. Then we will let go of the naming and dive right into the drawing.

Our eventual goal is to quiet the left brain so that drawing is totally a right brain activity, but that happens gradually and with practice. Drawing can flow like music once thoughts stop and allow us to respond freely.

The exercises above are to get you started drawing movement by imagining it first. Now you are ready to discover movement and to draw what you discover.

Discovering Movement and Drawing It

Chasing Movement around Your Shoe

Let's take that step now. Use the same shoe you used for the Cruising Exercise in Chapter 3.

Place your shoe about three feet from your eyes and in a location behind and slightly to one side of your drawing pad, so that you can see both the shoe and the pad by shifting your eyes between them, but without moving your head or body.

Before you begin, let's review what you will be doing. Remember, we are exploring movement now. That means instead of following edges, you are looking at what the edges are doing: curving in, curving out, falling, rising, swooping, swirling.

The first part these exercises will remind you of the Air Glide exercise introduced in Chapter 3. This new version is *Gesture Air Glide,* where you are finding what it is doing rather than its description. It lets you feel the movement.

The Gesture Air Glide

Movement: So that you will be ready to move from *discovering* the movement to putting it on paper, hold your pencil with your index figure aligned with its barrel while doing the Gesture Air Glide your pencil at the beginning of an edge.

The Exercise, Part 1: Discovering the Movement

1. Keep your eye and your pencil aimed at the same spot.
2. Take a deep breath (this is important), then with your eye following your finger, begin the waltz count 1-2-3, 1-2-3, and within that tempo, glide your finger along that edge to where it changes direction (no matter how insignificantly) on 1, back to your starting point on 2 and back to the direction change on 3.

3. Feel the movement as you mentally name it, pause slightly and move to the next segment.
4. Continue like this until you have felt and named all the movements in the shoe.
5. Stop. Take a deep breath.

Now that you have allowed the left brain to participate by giving it words (one, two, three; or forward, backward, forward again) that describe the movement you discovered, it is time to let the right brain feel and draw those movements. You have already named them. so you don't have to think about them anymore.

Exercise, Part 2: Drawing the Movement

6. Hold your pencil with your index finger extended along the barrel, pointing with the pencil point.
7. Place the point on your paper.
8. Take a deep breath, then let your open eye rest on your starting point of the shoe.
9. Think the waltz rhythm, then using that rhythm, begin moving your pencil to the waltz tempo, doing the fibfa maneuver for each new direction of the shoe's edges, with a very slight pause before each change of direction.
10. Once you've waltzed around all the edges, close your eyes and take another deep breath, then open your eyes.

I hope you smile. Are you smiling?

The "Correct Way" Myth about Drawing

Neither the Air Glide/Phantom Drawing/Cruising trio nor the Gesture Drawing activities have been described with instructions indicating that there a correct way to do them. They are experiences to be had if you choose, ways to help

you ditch your self-doubt and find drawing an exciting and fun venture. There are no time tables, no deadlines, nor any expectations. There is no right way or wrong way, better or worse way. There is only the involvement.

You can redesign any of these exercises or use them in any way you like. And, needless to say, you can use them to explore any subject whatsoever.

Being engaged in these approaches alone will lead you forward with drawing so long as you take them for what they are and refrain from judging or criticizing your results. It is the experience, the doing, that will empower your growth.

You might be entertained by going on-line and looking for the following drawings:

> *Saskia Asleep,* by Rembrandt van Rijn
>
> *First Composition Study for Guernica,* by Pablo Picasso
>
> *Study for Painting "La Comtesse Noire,"* by Toulouse-Lautrec
>
> *Two Brothers,* by Honoré Daumier.

You will discover within these master works the freedom and life found in pure movement. It is within the movement itself where we find the images.

Keep in mind that beyond these first tutorials, these exercises, what is added to your drawing skills is a matter of learning to manipulate tols and materials to help describe and interpret in more depth what you are seeing. There is no right or wrong way to do that either: the object is to become familiar with how the tools and materials behave, which is no different from applying makeup, zipping trousers, or spreading peanut butter.

For a good single source describing how drawing materials and techniques behave, I recommend *Keys to Drawing* by Bert

Dodson. This resource and others show you a variety of methods to make tools and materials work for you without your having to learn those skills on your own.

In the long run, the only correct way to draw is to put a drawing tool to paper and let it travel.

CHAPTER 9
Creative Freedom Is Imminent

*You become more powerful in whatever you do if
the action is performed for its own sake.*
—Eckhart Tolle

Any creation, even the universe within which planet Earth rotates, depends upon everything working together in order for even its smallest element to function without stress. Anything that interferes, whether a flat tire on a Porsche or dead battery in a smoke detector, slows down and sometimes endangers the welfare of whatever is depending upon it. The same is the nature of the creative process.

Everything that is true for even the most minute living cell is equally true for the entire universe. The creative process within each individual human is no exception. Five decades of teaching has convinced me that it takes very little to get that creative process working if the student can ditch the brain chatter and connect to the inner child that knows only the innocence of doing without fear of being judged. If we can summon, evoke that state of mind, all we need to add to the doing is more of the *how-to*. When a *how-to* becomes so habitual that we no longer have to think about it, we can add another *how-to* if we choose, and then yet another. There is no end our potential once we get started.

There is one more important link to making this discussion complete: How can we evaluate our work in light of all that I have said?

How Do We Evaluate the Work?

What Criteria Do We Use?

I opened this book by talking about individual uniqueness because I am convinced that at the core of finding *freedom to create* is unconditional acceptance of one's inner being. This kind of freedom influences all the choices we make, including the kind of artwork we will do. These decisions include whether we interpret what we see realistically, whether we transpose what we see into some kind of abstraction, whether our images come solely from our imaginations, whether we move toward a new invention, or whether we deal with images at all.

When an artist feels unconditional acceptance, there is no desire to imitate what others have done or to take subject matter from images that others have created, photographically or otherwise. On the contrary, the confidence of the inner artist grants a freedom to discover subjects that speak uniquely to the individual, as well as excitement of creating artworkthat is truly the individual's own.

So our first criterion for evaluation of our work has to do with its authenticity. Does it originate from within, or did it originate from some outer stimulus, such as a desire to belong to an accepted style, or a desire to please our viewers, or an imitation of what somebody else has done? In other words, is our work original, meaning did it originate from *I Am*? Is the style spontaneous, or is it affected by some trend or some other artist?

Next I addressed craft, because I affirm it to be the voice through which an individual's creativity speaks. When craft belongs to the artist without restrictions imposed by somebody else's rules, it is unconditionally available to speak through the individual's unique voice. Hence the next criterion for evaluation: How soundly is the work crafted?

Beyond this, I name the act of seeing as the artist's most essential resource, because it is through our vision, whether inner or our physical eyes, that ideas emerge, that

imagination churns, that inspiration flows. Creativity begins with an image, perceived or received. So the third criterion is closely related to the first two: How unconstrained is the whole piece?

If a work is freely expressed, it projects a feeling of confidence and authority rather than tentativeness. It will be fresh and spontaneous rather than stiff and overly worked. It will reflect the "freeness" with which it was created, piloted by the inner artist's inspiration.

These three components, authenticity, craftsmanship, and spontaneity, all guided by the dynamism of composing, give us perpetual fodder for discovery and expression. The act of *composing* is nothing more, or less, than a phase of assembling, of deciding the way we choose to construct our creation. It comprises the fourth criterion for evaluating the success of the work: Is it well composed?

Look back at the Results Generators listed at the beginning of Chapter 5. Those are the results of good composing. The questions we ask here are these:

1. Is it *unified*? Do all the parts belong together?
2. Is it *well-ordered*? Are the parts placed so that the whole painting is accessible to the viewer? Does the eye stay within the painting?
3. Does the piece have *harmony*? Is it in tune? Is there an overall sense of agreement? Is there at least one single element of consistency, for example, in similarity of shapes, or in overall temperature of color, or in repetition of movement?
4. Is the piece *balanced*? Does the eye move throughout the painting as opposed traveling off on one side or feeling a stronger gravitational pull on one either side?
5. Does the work have *rhythm*? Does the eye flow at a smooth pace throughout, the only interruptions being those that redirect the eye or cause a brief pause?
6. Is there *movement*, a visual path that the eye can easily follow?

7. Does the piece have *proportion*? Is anything in excess? Is there a sense that nothing is overdone, overstated? Is every part given enough attention? Does any image seem too large for its surroundings?

When to Evaluate

One warning: evaluation should never be done while you are in the act of creating, but rather at times when you take a break or suspect the artwork is close to being finished.

It is important that we not be misled by the idea that evaluating is judging. The concept of *judgment* is construed to mean finding what is right or wrong about something, or good or bad. This attitude of judgment isi an essential part of human life, but it can cause a bias, when misapplied to creative pursuits, that blocks creativity. On the other hand, to *evaluate* means to examine how well something is working, to look forward, to keep going. To judge is to stop cold and glare at what is perceived to have gone wrong. Negativity has no place in the creative process.

And from What Standpoint

Another thing to remember is to avoid identifying yourself with the work you are doing. By that I mean that we are all in the process of learning. What we understand and what we do with that comprehension enables us to apply what we know. What we have yet to learn will present itself in our evaluation or own work. This prospect has nothing to do with who we are, neither is it a comment about our worth. It simply tells us what we need to learn.

It is also important to remember that when doing student assignments, the goal is to learn whatever is being taught. This is practice time, not creative time. The learning process should never be confused with the creative process except to the degree that the experience of either adds to the artist's toolbox. Evaluation in the classroom should focus on how well

a concept was grasped, how well a technique was captured. Creative breakthroughs during that process are a bonus.

Further concerning evaluating, let me emphasize again here two ideas that we all would do well to embrace right now and recall often.

There Is No Correct Way to Paint

Painting materials and tools have predictable ways of behaving. So when we are grasping the mechanics of a new painting medium, we're in the *how-to* mode, finding out its way of behaving and learning to guide it. This means that there is no correct way to paint. But there is a system for how to handle confidently any painting material. It helps to know how it works. It is no different from determining how to brush your teeth or make a cup of coffee.

Being correct is a flaw in thinking. It's a left brain concept that came from somewhere outside the world of art. It's a restrictive way of thinking imposed by a social convention that holds correctness as being more important than humanness.

The definition of *correct* is *free from error*. There is nothing whatsoever about *free from error* that in any way relates to painting or making music or dancing or writing or any creative endeavor. Errors pop up all the time. In fact, within an artwork they often create a tension that makes a work intriguing.

Every master painter and every concert musician accepts as a given that a work or a performance will not be error free. It is the novice who gets uptight about making errors, not the mature artist. Actually, the more comfortable an artist is with a chosen medium of expression,[30] such as music or painting or dance, the more relaxed the artist becomes about the whole error issue. It just doesn't matter. And the irony is that fear of making errors is often what causes an error to be made, and further errors to proliferate.

[30] *Medium* means anything used to create whether a musical instrument, a dancer's body or an artist's paint.

There Is No Correct Way to Create

The creative process has been a favorite subject of mine since I became a teacher. One of the first things that I noticed about my students was the individual ways in which they went about doing their work, the myriad of results from the same set of instructions from me.

At the same time, I was drawn to journals and notebooks by artists, writers, and musicians, each so different yet all having a single universal spirit, which led me to realize that creativity is an extension of life. The fifth word in the Christian Bible is *"created,"* the first chapter of the classic Chinese text *I Ching* is "The Creative": creativity is the single thread that weaves throughout all that lives.

I think of the artist as a filter through which things are processed and transformed into something new. I reject current notions that subject matter can become a cliché: a cliché results from the way something is used, not the entity itself.

The subject of a mother nursing a child is a cliché only when it is an imitation of how others have presented it. But when the response comes from the inner artist and is presented through unique, individual expression, particular set of skills, and choices of interpretative generators, it is a new creation, not a cliché.

The notion that an old song has to be reset to jived up rhythms and off-key contortions is hogwash: no matter how old the song, an unaffected voice streaming directly from the heart can bring new life to it.

To create, we simply respond from the innermost self and with whatever skills are currently available. We ignore current trends and voices that would have us bend and twist our own voice toward theirs. We begin with our own intention and end with our own affirmation. There is no correct way: we prepare ourselves and just do it.

What Makes a Masterful Painting?

There's an argument as old as painting itself, an argument I have heard hundreds of times defended from opposing points of view: What makes a masterful painting?

As I write this, I'm listening to guitarist Sharon Isbin playing "Wild Mountain Thyme." It's a haunting yet simple little tune. I've heard it played so badly I wanted to scream. I've heard it rendered with such mediocrity I'd stop listening. And I've heard it played with so much improvisation that the tune itself became insignificant. But Sharon Isbin plays it masterfully.

What Isbin does with "Wild Mountain Thyme" on guitar is no different than what a master painter does with a brush, paint, and canvas. My stance is that a masterful painting requires the same degree of skill, competence, authority, and knowledge called for by an Olympic figure skater, a concert violinist, or a champion baseball player.

Thousands develop competence, but few among them become masters. It is only when one can learn to relax within one's own competence that real mastery emerges.

A masterful performance in any genre happens when verse becomes poetry, when scores become music, when form becomes art. It happens when the artist becomes so comfortable with craft as to move beyond technique into pure expression while fully utilizing the technique. It happens when craft becomes the means, not the goal. Mastery can never come from an attitude of "look what I can do," only from an intention of "where can I go next?"

Mastery is possible at any level of experience during the process of evolving one's craft. It is not something that happens all at once at the end of a long process of development: one does not study for years, then become a master. That's not how it works. Mozart was composing successfully at age five. Michelangelo created *Madonna of the Stairs* at age seventeen.

But neither Mozart nor Michelangelo stopped learning. In fact, the more competent each became, the more each saw to be discovered within his chosen craft. And even though Mozart

died young and Michelangelo lived into old age, at the end of each of their lives, neither felt he had done much beyond scratch the surface. That's the attitude of a master.

One characteristic I have observed in a number of masters is playfulness and openness to all possibilities. Itzhak Perlman enjoys playing "Turkey In the Straw" with as much zest as he does a Chopin mazurka. Charles Schulz scribbled on envelopes and came up with *Peanuts,* perhaps the famous and long-lived daily cartoon series. Leonardo experimented with wax on *The Last Supper.* There is a childlike humility that can find expression and joy within the most simple of subjects, and there is innocence from awe of the most honored.

So to answer what makes a painting masterful, I think it is the degree to which the artist is willing to let go. There's no question that mastery requires devoted hours learning and developing craft step by step, building one degree of skill on top of another, processing what one discovers, experimenting with possibilities, internalizing the principles that make it work, discarding the superfluous, refining and building on what does work, revisiting what didn't work before--all this and more. But I am convinced that within and during all these hours of involvement, it is the letting go that makes the difference. It is when the potential master totally relaxes within and allows it all to work together that the truly great can manifest.

Mastery can happen at any moment when artist, craft, and instrument become one. At that moment, finding freedom to create is no longer an issue.

EPILOGUE

Nature as Our Guide

We have within creation itself all that we need to guide us, to show us in cycles what freedom to create looks like. Since childhood, I have been amazed at being able to hold in my hand a tiny object capable of becoming something many times larger than my own physical body, and with seemingly effortless ease: an apple seed.

Release for a moment all your intellectual bias toward what our culture calls cliché and give your imagination and attention to the act of eating an apple. Once you have made your way, bite by bite, through the fruit itself, place your attention on those seeds within its core. There are several, each with potential for becoming an apple tree, itself with potential for producing thousands more apples. We humans are not any different in our capacity to create. We need only the same moment-by-moment *attention to being* that an apple seed needs to sprout, grow, become a tree and make more apples.

And the kinds of things that prevent any stage of that process from happening are the same kinds of things that block our creativity. Those, too, are the same phenomena that block our being able to experience full joy, from being truly the *I am* we were born to be.

The freedom we can experience in *gesture drawing* alone (Chapter 8) will give us a link to our inner core of expression. Gaining a carefree attitude while practicing the Air Glide, Phantom Drawing, and Cruising exercises described in Chapter 3 can liberate our inner ability to capture and manifest a response to what we see that arises from our individual uniqueness, uncontaminated by any outside restrictions. Making ourselves conscious that composing is a vital and

life-enhancing process gives us freedom in the way we choose to assemble our images. We confidently and effectively reflect our deepest feeling and find within ourselves unimagined potential.

And then, when we approach every subject as if we have never before seen it, and every act of creating as if we have never before done it, the universe is forever new.

We are full of unlimited potential.

Going Forward

It is that uniqueness in each of us that defines our purpose for being here. It is the most precious gift we have, and when we fully give it our attention and spend our time claiming it as who we are, when we refuse to allow it to be camouflaged, we give to ourselves the freedom fully to experience our purpose.

Preparing ourselves is the easy part. We have available to us multiples of resources from which and from whom to study craft and composing. All we need do is to start doing.

And while we are doing, perhaps we would do well to recall Danish poet Hans Christian Andersen's story *The Ugly Duckling* to remind ourselves that we are all not unlike the little hero there, who did not know, until at last he saw his reflection in the water, that he had been a swan all along.

ACKNOWLEDGMENTS

More goes into writing a book than crafting words. This one materialized because of the many students who over a span of fifty years have given back to me more than I have taught them, whose enthusiasm has filled me with creative energy that makes teaching work.

Combine this with my family, whose unconditional love has played a huge role in all my creative work—my life partner, the late Dr. Howard G. Hanson, brother and sister-in-law, Bill and Vickie, nephews and niece, Weston, Cole, and Monica, and grandnephews, Jaxon and Ryley. Their unrelenting love, encouragement, their cheering me on and total support, has been my mainstay. And of course my schnauzer, Maggie, who patiently lay at my feet during the many hours of writing.

And my family of artists and perpetual cheerleaders—Annice, Amy, Betty and Mary, Cathy, Cindy, Cynthia, Donna, Gail, James, Lilith, Linda O., Linda S., and Robie—who share the joy of painting with me the second Tuesday of every month. Their devoted participation in my weekly tutorials continue to teach me.

Cathy Hauck can never know how grateful I am to her for the endless hours she spent thoroughly editing, validating points of reference and making me stop when it was time to stop. And multiple thanks to Laura Oaks and Hal York for further editorial attention.

My deepest gratitude to Elijah, Caleb, Eiva, Freia, Issac, Sophie, Sylvia, Lily and Hal for sharing with me their lives and their creative process.

Many thanks to Gaye Sekula, Linda Coggins, Catherine Jo Morgan, Sheilah Welsch, Angelina Bellebuono, Diane Hooker, Linda Conway, and my Second Tuesday Art Guild for taking the role of guinea pigs, testing out the drawing tutorials: I am so grateful to you.

Finally, it has been a pleasure working with the folks at Balboa Press. They have carefully and attentively guided me through the publishing process. And many thanks to the design teams for their excellent work.

And to you, the person who read this book. Thank you.

RECOMMENDED READING

Arnheim, Rudolf. *Art and Visual Perception.* Berkeley and Los Angeles: University of California Press, 1954.
Brach, Tara. *True Refuge.* New York: Random House, 2013.
Cameron, Julia. *The Artist's Way.* New York: Penguin Books, 1992.
Csikszentmihalyi, Mihaly. *Flow: The Psychology of Optimal Experience.* New York: Harper Collins, 1991.
Dodson, Bert. *Keys to Drawing.* Cincinnati: North Light, 1985.
Edwards, Betty. *Drawing from the Right Side of the Brain.* Los Angeles: J. P. Tarcher, 1979.
Feldman, Edmund Burke. *Art as Image and Idea.* Englewood Cliffs, N.J.: Prentice-Hall, 1967.
Franck, Frederick. *The Zen of Seeing.* New York: Vintage Books, 1973.
———. *Zen Seeing, Zen Drawing.* New York: Bantam Books, 1993.
Genn, Robert. *The Painter's Keys.* Surrey: Studio Beckett, 2003.
Ghiselin, Brewster. *The Creative Process.* Berkeley and Los Angeles: University of California Press, 1952.
Goldstein, Nathan. *The Art of Responsive Drawing.* Upper Saddle River, N.J.: Prentice-Hall, 1999.
Gurney, James. *Color and Light.* Kansas City, Mo.: Andews McMeel, 2010.
Henri, Robert. *The Art Spirit.* New York: J. B. Lippincott, 1923.
Nicolaides, Kimon. *The Natural Way to Draw.* Boston: Houghton Mifflin, 1941.
Schmid, Richard. *Alla Prima II: Everything I Know about Painting—and More.* Expanded edition, with Katie Swatland. Lancaster, Pa.: Stove Prairie Press, 2013.

Taylor, Jill Bolte, PhD. *My Stroke of Insight*. New York: Viking, 2008.
Tolle, Eckhart. *A New Earth: Awakening to Your Life's Purpose*. Vancouver: Namaste, 2005.

ABOUT THE AUTHOR

Dianne Mize is a lifelong artist and has been a teacher of painting and drawing for the past fifty years. She began as a high school teacher in Visual Art and English. Later she taught in Georgia's Governor's Honors Program for six years, having chaired the Visual Arts program for four of those.

She chaired the Department of Visual Art at Piedmont College for ten years before co-founding with her life-partner, the late Dr. Howard G. Hanson, the *Dianne Mize Studio*, where she taught until her retirement in 2007.

Dianne holds a Master of Fine Arts degree in Painting and received an undergraduate minor in music. Music has been as important to her as painting. During her years in Governor's Honors, she devised a course called *The Creative Process* exploring how all creative acts flow through a similar process of becoming manifest even though the results might be vastly different.

Her investigations in the creative process confirmed her teaching philosophy of Individual Uniqueness asserting that when an individual is responding from his or her deepest innermost self, the results will be unique no matter their subject or genre. It is her insistence on claiming this uniqueness that has been the trademark of her teaching methods.

Dianne lives in the foothills of the Appalachians in Northeast Georgia with her schnauzer, Maggie. She continues to paint, write, play her hammered dulcimer and enjoy the mysteries of nature that surround her.

Join Dianne in her myriad journeys at www.diannemizestudio.com.

www.ingramcontent.com/pod-product-compliance
Lightning Source LLC
Chambersburg PA
CBHW032019170526
45157CB00002B/761